PRESENTING ARCHITECTURAL DES

Published in Great Britain 1990 by
Architecture Design and Technology Press
(a division of Longman Group UK Limited)
128 Long Acre
London WC2E 9AN

© 1988 W.D. Meinema BV
Original title: *Architectuur / Presentatie*
Publisher: Waltman, Delft

ISBN 1 85454 701 1

British Library Cataloguing in Publication Data
A CIP catalogue record for this book is available from
the British Library.

Designed and printed in The Netherlands by Meinema,
Delft.
This book has been published partly as a result of
sponsorship by Grabowsky & Poort BV, The Hague.

PRESENTING ARCHITECTURAL DESIGNS

Three-dimensional visualization techniques

KOOS EISSEN

Architecture Design and Technology Press
London

Foreword

Everyone involved in architectural design needs to know about the variety of presentation techneques that are available. An architectural design will have to be presented to the client or displayed to the 'public' and communicated in the architect's office during the progressive phases of the design process, from the initial concept to the final scheme.

Specific media techniques, which are based on a design language, have been developed for each of the disciplines in the building industry. Special training is needed to understand certain design languages, which are used in the various phases of design development; in other fields this might not be necessary. The building contractor for instance is quite familiar with plans because he has learned to read the standard codes. However, he may have little use or three-dimensional computer-animated drawings, even though he will be quite capable of interpreting them. On the other hand, clients, local authorities or housing associations can better interpret perspectives, computer-animated drawings and models than elevations, sectional drawings and plans.

When presenting a design, the designer should consider what he wants to communicate and the client for whom the information is intended. His success will depend on his familiarity with various media techniques and their applications.

New techniques are constantly being developed. Computer-animated drawings have barely made their entry into the field of architectural design and we are already confronted with experiments in the field of holography. Basically all rendering techniques are related to human observation and the objective is to make these designs accessible to as many people as possible. We should be careful however. In general, people still find it difficult to work with the images produced by the latest design tool, the computer. The computer can solve many design problems. However the input of wrong viewpoints or insufficient input produces confusing images. The computer needs to be given very precise instructions in order for it to produce a coherent design.

This book has been produced as part of the project 'Visual Communication in Construction', set up by the Media Division of the Department of History, Media and Theory of the Faculty of Civil Engineering, University of Delft.

A broad and hopefully inspiring overview of the media techniques used in the building industry is given, together with a detailed description of these techniques. Special attention is given to perspective drawing. Once, drawing in perspective has been mastered, the technique becomes an excellent means of communication. Expertise in this technique can also stimulate a designer's three-dimensional awarenes.

I am indebted to Ad van Dijk for his unremitting help as proofreader and his professional advice. I am also grateful for the substantial contribution by the engineering firm Grabowsky & Poort The Hague, which has made it possible for some of these illustrations to be produced in colour. Considerable assistance was received from Arcade O'Harris, Woerden, where the Arkey CAD program was devised. This was used to produce most of the drawings in this book. Finally, I would also like to thank all those who donated drawings and photographs.

February 1988 The Author

Contents

The evolution of perspective space representation

Although prehistoric drawings reflect intentional or unintentional attempts to convey perspective space, it is generally believed that artists in ancient Greece were the first to study the problem in depth. Observation played an important part, while there is also evidence of an interest in a theoretical foundation. Propositions laid down by the mathematician Euclid in about 300 B.C. point to attempts to arrive at definitions. He concluded, on the basis of observation, that a circle, viewed from a particular angle, is presented on the retina as a straight line.

Greek vase drawings give a good indication of the evolution of perspective space representation. Three vase drawings, which are presented in chronological sequence, are testimony to the struggle involved in perspective space representation. Each of the three vase drawings depicts a chariot and a team of horses. In Figure 1 perspective space is represented schematically by placing the objects at right angles to each other. Horse and chariot are shown in profile while the horses' heads are at a 90° angle to their bodies. The wheels of the chariot are presented as straight lines and the round shield, held by the warrior standing next to the horses, faces forward.

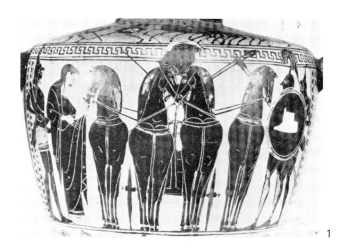

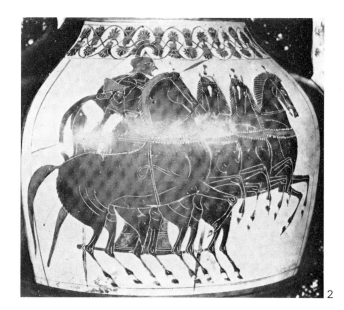

Examples of the evolution of perspective space representation in drawings of a four-horse chariot on vases in the so-called 'Attic black-figure style', circa 300 B.C., Greece.

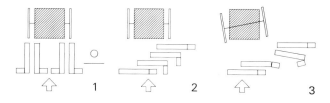

In Figure 2 an element of movement has been introduced into the image. However the objects are still set at right angles to each other. The chariot is moving forward but the charioteer faces sideways. The two outer horses are shown in profile while the two middle horses have their heads turned to the front.

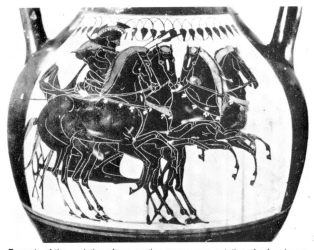

In Figure 3 perspective space representation has become freer. Other directions have been incorporated. The wheels are elliptical and this phenomenon produces a near-perspective effect. The plan clearly demonstrates the larger graphic freedom.

Roman murals in the so-called Second Pompeian Style – approximately 50 B.C. – show the further advance made over the centuries. The vanishing point, the point of convergence of the perspectives of all orthogonals, has been discovered. An accurate definition is still needed.

3

Example of the evolution of perspective space representation of a four-horse chariot on a vase in the so-called 'Attic black-figure style', circa 300 B.C., Greece.

Mural in a villa in Boscoreale on the bay of Naples. The scene has probably been influenced by Greek theatre scenery. None of the parallels converges to a central vanishing point.

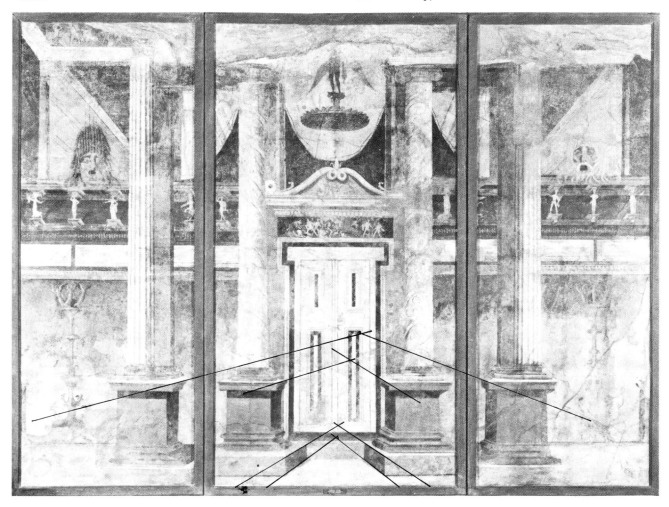

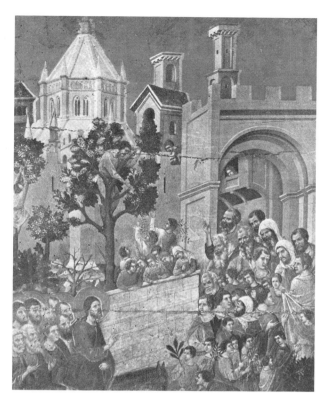

There was virtually no interest in perspective space representation in the early Middle Ages. A revival of perspective did not occur until the 13th century. The representation of architectonic space – as a background to religious scenes – completely lacks a theoretical foundation and the perspective is drawn by eye.

The new perspective theory was interpreted in Italy by painters such as Cimabue and his apprentice Giotto. In addition to illustrations of buildings using a single-point perspective projection, paintings can be found where certain objects are represented at an angle.

Duccio di Buoninsegna, *The Entry into Jerusalem* (detail), 1308-1311, Museo dell'Opera del Duomo, Siena.
An illusion of space is given by placing the buildings on the picture plane without a logical application of the rules of perspective.

Giotto, *The Resuscitation of Drusiana by St. John the Evangelist* (detail), post 1317, Santa Groce, Florence.
A more realistic perspective representation of the buildings is achieved here than in the paintings of Buoninsegna, which reinforces the illusion of space.

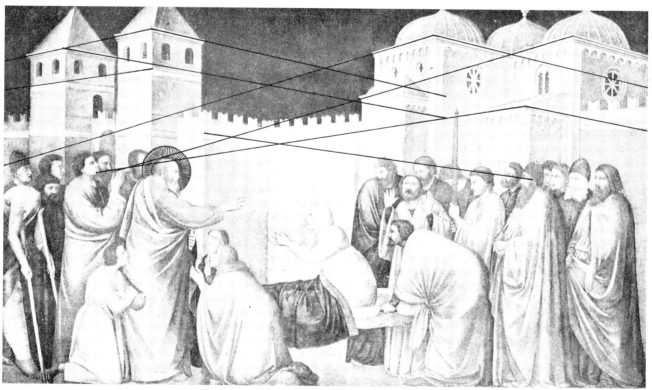

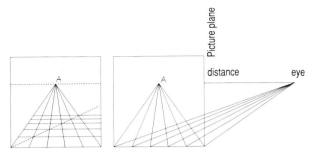

Perspective construction of a three-dimensional grid by Alberti. A diagonal was drawn across the foreshortened grid to prove that the diagonals of the individual squares formed into continuous straight lines without taking any specific image width into account.

panels depicts the Piazza del Duomo in Florence from a fixed viewpoint. The scene must have been realistic because it has often served as a model. Regrettably, both panels have been lost but fortunately Manetti, Brunelleschi's apprentice, has given a minute account of their details.

In 1435 Leon Battista Alberti published his *Della Pittura*, a theoretical treatise on perspective. He established:
– that there is no perspective distortion of straight lines;
– that orthogonals converge to a single vanishing point, dependent on the fixed spectator point;
– that objects decrease in size in an exact proportion to their distance from the spectator, so that all quantities are measurable.

The theoretical foundation underlying perspective representation on a flat surface was developed further in the Renaissance. The architect Brunelleschi (1377–1446) demonstrated his knowledge by painting two 'perspective demonstration panels'. One of these

Paolo Uccello, sinopia (underdrawing of a fresco) 1446. The perspective construction of a three-dimensional grid without taking any specific image width into account.

In contrast to the method of their counterparts in the Middle Ages the Renaissance painters first made a perspective construction as a starting point for pictorial composition and subsequently painted in the figures. The use of the rules of perspective should result in a balanced composition.

Leonardo da Vinci (1452–1519) wondered how it was possible that in a row of columns, drawn from a fixed viewpoint close to the picture and using the adjoining building, the projected width of the two outer columns appears to be larger than that of the middle column,

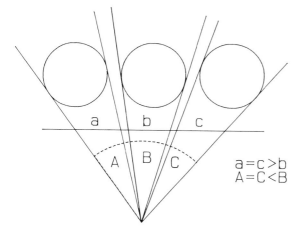

$$a = c > b$$
$$A = C < B$$

whereas one would expect that the width of the middle column, being the closest, should have been larger. He suspected that the phenomenon was caused by the fact that the curvature of the retina had not been taken into account. The scene should actually be projected onto a curved picture plane which implies that straight lines must now be drawn as curved lines. He reached three conclusions:

- an object drawn from a fixed viewpoint close to the picture appears realistic to the spectator if he chooses a viewpoint which corresponds to that of the artist. The drawn object can therefore only be viewed by one spectator at a time. Any other angle of view would produce distortion.
- if the scene has to be viewed by more than one person at one time then the artist must choose a wider angle of view.
- if a narrow angle of view has to be used without a fixed spectator point then it is recommended that all identical objects parallel to the picture plane should be given the same dimensions.

Leonardo da Vinci, background study for the *Adoration of the Magi*, circa 1481, Uffizi, Florence. It is clear that Leonardo da Vinci also used the Alberti method by first designing a three-dimensional stage and subsequently introducing the figures.

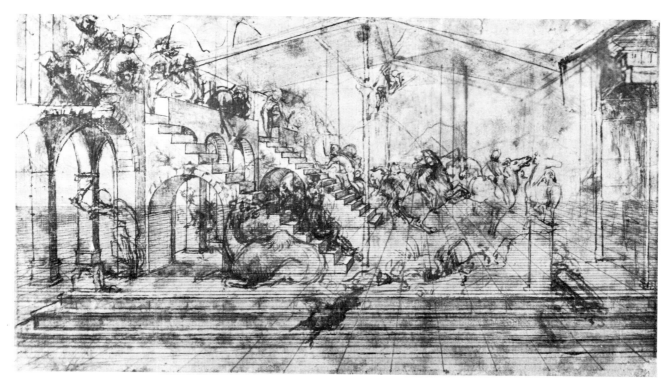

Albrecht Dürer, *A man drawing a recumbent woman*, 1525. Tracing from observation through a transparent frame, covered with a network of lines forming into squares which correspond to the squares on the drawing paper. The woman's contours are drawn on to the corresponding squares on the paper.

The famous theoretical perspective engravings of Leonardo's contemporary Albrecht Dürer (1471–1528) have made a significant contribution to the dissemination of the theory of perspective construction that evolved in Italy. This theory has remained virtually unchanged up to the present day.

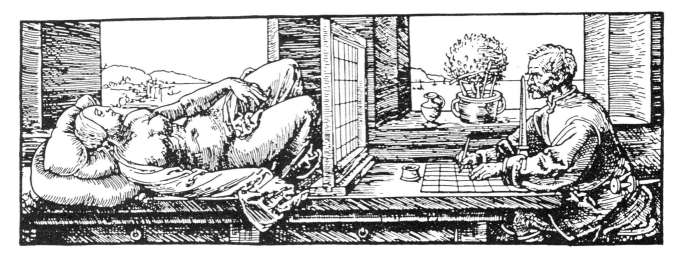

American projection

European projection

Projection methods

We can choose from several projection methods to draw three-dimensional objects such as a building or series of buildings to a given scale on a flat surface. The three-dimensional shapes can be projected either at 90° or at a smaller angle to the picture plane.

The principle projection methods are:
– orthographic or orthogonal projection;
– oblique projection;
– perspective projection.
These methods are discussed in chronological order.

Orthographic or orthogonal projection

When drawing in orthographic projection the various views of the object are projected parallel to the picture plane – an imaginary transparent surface, at right angles to the direct line of vision. Orthographic projections thus show faces as true shapes and their true measurements can be obtained by using a scale rule.

The views are arranged in a specific order. The side views are represented to either side of the front view, the rear view is then projected to the right or to the left of the side view. The plan and the roof plan are projected below and above the front view respectively (American projection). The various views are controlled by tracing horizontal and vertical auxiliary lines.
In some cases, aspects of a view are set at an angle. These faces or aspects of an object will appear foreshortened. The true measurements can be interpolated from one or more related views. Some artists deliberately choose to draw an object at an angle to stress the plasticity of a building or to show angular connections. To achieve this, the plan is rotated in relation to the picture plane.

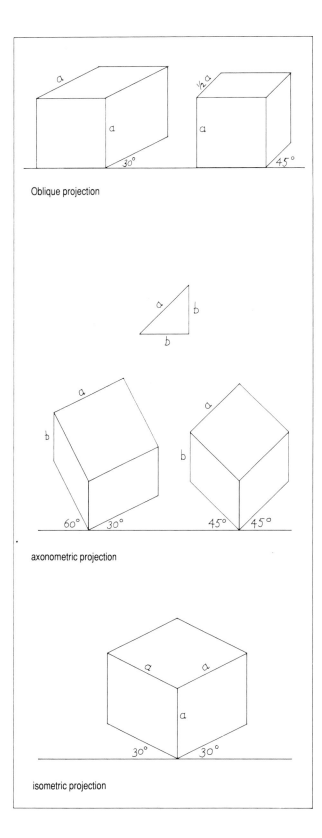

Oblique projection

axonometric projection

isometric projection

Oblique projection

In oblique projection a three-dimensional shape is represented at an oblique angle from either above or below such that the parallel edges remain parallel to the picture plane.

Oblique projection was used to give a three-dimensional appearance to objects yet in such a way as to allow length, breadth and height to be measured.

There are three methods:
- In *oblique projection,* the frontal plane is drawn in orthographic projection and the top plane and one side plane are drawn at an angle of 30° or 45° to the picture plane. If an angle of 30° is used then the true dimensions are obtained. When using an angle of 45° the depth is halved in order to avoid optical distortions.
- in *axonometric projection* a plan view of the object is first drawn in orthographic projection and the end elevations are drawn at angles of 30° or 60° or both at angles of 45°. The horizontal edges are shown as true lengths; the verticals are foreshortened. Axonometric projection can be used as a substitute for a 'bird's-eye view' perspective. The latter comes closest to the realities of the way we see things, but is more difficult to draw.
- in *isometric projection* both lateral planes are drawn at identical angles (for example 30° angles) and all edges are shown as true lengths.

Axonometric projection and *isometric* projection are usually used for architectural drawings. Perspective of building volumes is rendered accurately and the edges are not noticeably foreshortened. Isometric projection comes closest to the realities of the perceptual process.

In *dimetric* projection two of the axes of a rectangular object are equally foreshortened, whereas in *trimetric* projection all three axes are foreshortened.

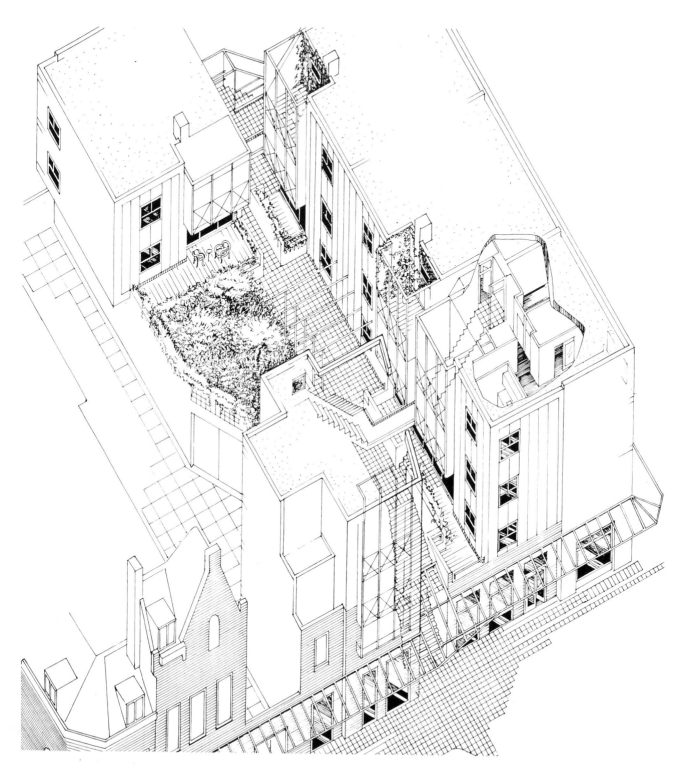

Architect: Peter Luthi, Rotterdam, axonometric study Zwaanshals Rotterdam, drawing in ink.

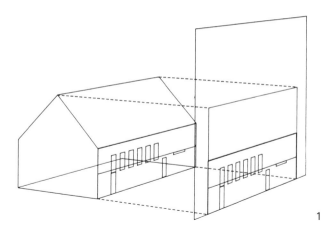

1

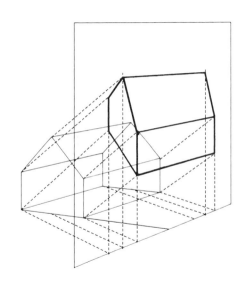

2

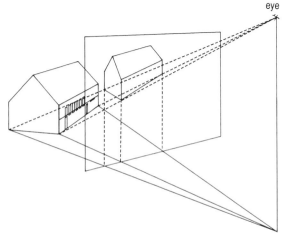

eye

3

Single-point perspective projection

Orthographic and oblique projection are metric projections which allow the length, breadth and height of an object to be measured or interpolated. Drawings prepared by using these methods of projection do not agree with the associated image on the retina of the human eye. A rod close to the eye appears larger than the same object viewed at some distance. This diminution is referred to as foreshortening.

Single-point perspective projection is a method used to produce a representation of an object which is congruent to the retinal images of the object.

In orthographic projection we use parallel projection lines which intersect the picture plane – the imaginary transparent plane at right angles to the direct line of vision – at right angles (drawing 1).

In *oblique projection* the object is distorted and the parallel projection lines also intersect the picture plane at right angles (drawing 2).

In single-point perspective projection, *sight-lines* from the eye to certain points of the object are used. These lines are projected to intersect the picture plane, and are marked by object points which show the object in perspective when linked to each other in the correct manner (drawing 3).

Object distance

The naturalistic rendering of a three-dimensional object is governed by the field of vision within which the spectator can see objects in sharp focus from a fixed viewpoint. In general it is assumed that this field of vision lies within a flattened cone, where the *visual angle* is 30° long and 45° wide. The larger horizontal visual angle is a result of the binocular vision of man.

Because the perspective formula is monocular – similar to a sense of space experienced by a one-eyed person – the angle for the *cone of vision* is restricted to approximately 30°. This implies that an object should be viewed from a correct spectator point – the object has to fall inside the cone of vision – if it is to be drawn convincingly.

Eye-level and scale

A horizontal plane can be assumed using the viewpoint. The intersection line of this plane with the picture plane is the horizon. In other words:
When an observer looks straight ahead the horizon is at eye-level and is seen as a straight line. The curvature of the earth is not taken into account.
The horizon is thus always a horizontal line which is at right angles to the direct line of vision. The average person is 1.70 to 1.80 metres tall, giving a standing person's eye-level of 1.60 to 1.70 metres.

If a person sits down then the horizon advances; if a person climbs a tower then the horizon recedes. In order to be able to interpret a drawing or a picture it is necessary to know the viewpoint. A drawing of a miniature house in Madurodam, drawn by a standing artist, can appear identical to a drawing of an ordinary house, drawn from the fifth floor of a block of flats. The inclusion of a person gives us a clue to its scale and enables us to infer its true dimensions.

We can distinguish between two different types of scale: *absolute* and *relative scale*.
The absolute scale of a building is determined by the proportion of the human body and its relation to the structure as a whole or parts of that structure.
Relative scale is dependent on the inconstancies inherent in human observation, where circumstances such as the type of environment, the incident light, the viewpoint of the spectator and the speed at which the observer is travelling can play a role.
Even though an absolute scale is used in perspective construction, the finished drawing will always contain elements seen at a relative scale.

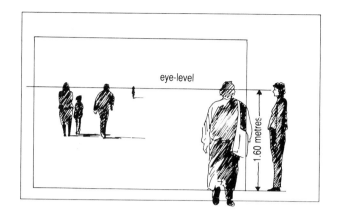

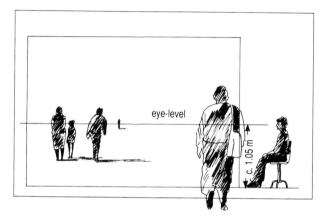

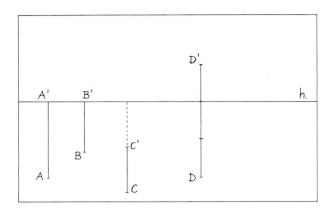

For example, a vertical rod, oriented in the ground plane with its upper point level with the horizon, has a length of 1.60 metres if we assume that the spectator's eye-level is 1.60 metres (rods AA' and BB'). Rod CC', which lies with point C on the ground plane, is located half-way between the ground plane and the horizon and is 0.80 metres long. Hence it follows that DD' which appears three times as long has a length of 2.40 metres.

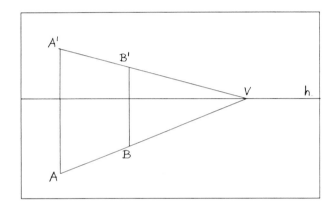

When we join the lower and upper points of the two identical rods AA' and BB' and we continue these connecting lines, it appears that they converge on one single point on the horizon. This point, V, is the vanishing point of all the lines which run parallel to the horizontal rod AB. All vertical rods, located between AA' and V, are in reality of equal length.

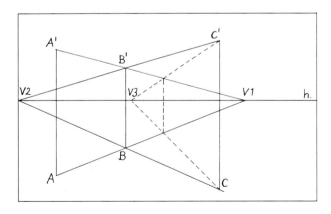

If we draw point C at an arbitrary distance in the ground plane in the same drawing and we draw a line from C through B to the horizon we generate a vertical rod in the ground plane which is equal in length to AA' and BB'. We obtain point V_2, the vanishing point of all lines parallel to CB. When we extend line V_2B' we find C' at the desired height. In a drawing with several vanishing points we can call these points V_1, V_2 etc.

If V_2 is positioned off the diagram – which would have been the case with line CA – then another vanishing point can be selected. This is illustrated by the dotted lines in the drawing.

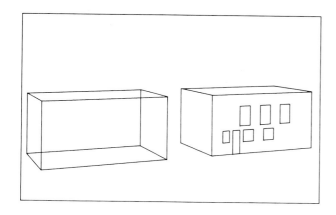

The dimension of the block drawn in the left-hand corner is not known. Clues to its scale, such as a door, are missing. When a door is added we can recognize a house in the block and establish the dimensions.

If we compare the three house-like shapes a, b, and c, which are drawn in similar perspective, it is easy to recognize a house in drawing a, a much taller building in drawing b and a kennel in drawing c.

The spectator's viewpoints differ in both height and in distance.

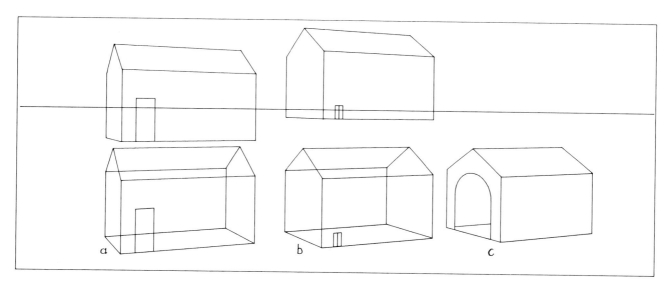

The height of buildings can be calculated relatively accurately using doorways as clues to scale. The ridge height of the tallest building in the middle figure is approximately 12.80 metres and that of the kennel approximately 1.00 metre.

The height of buildings in photographs can be determined with the aid of such clues to scale.

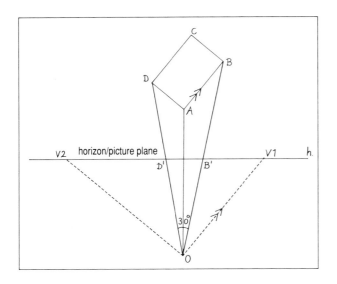

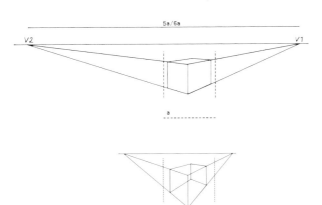

Vanishing points in relation to image width

The object to be drawn should be viewed from a correct viewpoint, so that a true rendering of the object is given: i.e. true to the actual appearance (see also page 16). Given a visual angle of 30° we can calculate the relationship between the vanishing points and the image width.

This is demonstrated in the following example. A rectangular block is drawn in plan view. The distance to the object is determined by a visual angle of 30°. The picture plane is located at an arbitrary distance between the object and viewpoint O. The *visual rays* OB and OD produce points B' and D' on the picture plane. B'D' is the image width of the object. The vanishing points V_1 and V_2, which are necessary to construct the object in perspective are found by drawing lines from O which run parallel to AB and AD respectively. The distance between V_1 and V_2 appears to be approximately 4.5 times the image width.

For a realistic representation, choose an image width a which leaves some space on either side of the object. As a rule of thumb, the image width should fit approximately 5 times between V1 and V2.

When the vanishing points are located closer to each other than 5 times the image width, i.e. when the visual angle exceeds 30°, the drawing can be distorted by the so-called *wide angle effect*, a phenomenon which can clearly be seen in the aerial photograph of New York. In this case the parallel horizontal lines converge as do the vertical lines. They are seen by the eye as diagonals but this image is corrected by the brain. We therefore experience these lines as verticals.

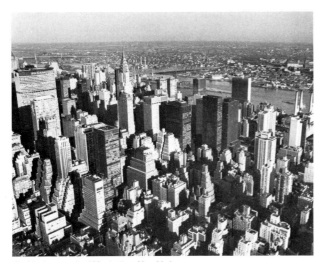

Aerial photograph of Manhattan, New York

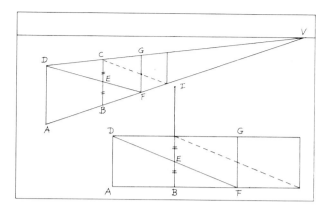

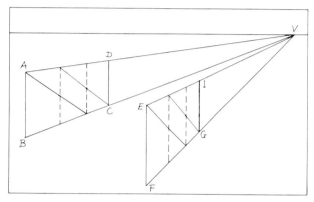

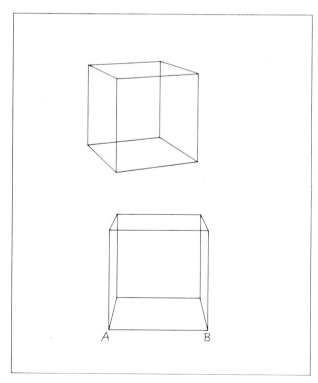

Foreshortening

Rods of identical length appear shorter when they recede from the eye. Regular foreshortening can be constructed.

The left-hand figure shows the method for reproducing of the vertical rectangle ABCD. This is the same method used in plane geometry for the multiplication of rectangles. By bisecting line BC and extending DE, the extension of line AB intersects in F. BF, which is in fact equal to AB, has now been foreshortened. A series of regular foreshortened lines are obtained by repeating this process. For reasons which we previously discussed on page 20 we assume that vertical lines do not recede. E therefore is the exact centre of CB.

Vertical squares and rectangles in perspective

Once the skill of drawing a vertical square from several angles has been mastered, it is possible to construct true rectangles of previously fixed proportions by multiplication. In the middle figure, ABCD and EFGH are rectangles of which the height and breadth are in the proportion of 1 to 3.

The spectator's viewpoint

There are two different viewpoints from which the spectator can see an object:
- from an oblique angle, whereby two side planes and the top or the bottom plane are revealed to view;
- from an acute angle, whereby the frontal plane and the top or bottom plane are revealed to view.

In the first case all planes are foreshortened, in the second case all planes are foreshortened with the exception of the frontal and rear plane. These two planes are not foreshortened because the observer is at right angles to the object. Line AB runs parallel to the picture plane and has two vanishing points in infinity (see page 24).

The angle of view

The angle of view changes for each cube in a column of stacked cubes. It is viewed from above or below. The height and the breadth of the lateral faces are the same for each cube.

The dictating angle

If the direct line of vision changes, then the dictating angle changes as well. A cube can thus be drawn from several angles. The breadth of the lateral faces differs in this case.

horizon

The angle of view

The dictating angle

Perspective construction

There are several methods for perspective construction such as:
- the radial projection method which is a precise method;
- the cubic method which is an approximate method.

The radial projection method

The radial projection method has already been discussed on page 16. It is based on the use of sight lines from the eye which connect the viewpoint with all important points on the drawing.

The drawing opposite shows the customary arrangement:
- the *ground plane* G. This is the horizontal plane on which the spectator stands. In many cases the object being drawn is also located on this horizontal plane;
- the *picture plane* T;
- the *ground line* GL. This is the intersection line in which the picture plane and the ground plane meet.

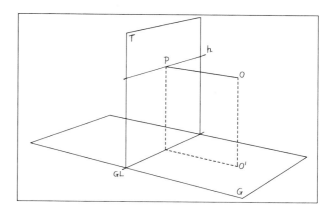

- the *eye-level* O. O' is the projection of the eye on the ground plane;
- the *horizon line* h;
- the *distance* OP. This is the shortest distance between the eye and the picture plane. Point P is thus the intersection point of the picture plane and the sight line is called a *distance point*.

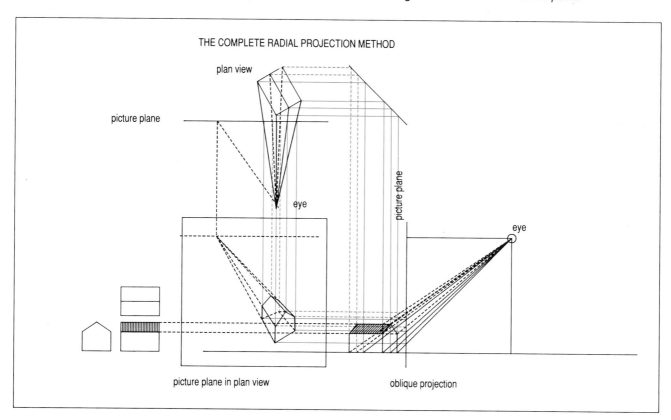

THE COMPLETE RADIAL PROJECTION METHOD

plan view

picture plane

eye

picture plane

eye

picture plane in plan view

oblique projection

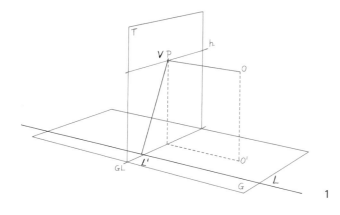

Vanishing point V

1. To obtain the vanishing point of a horizontal straight line L which intersects L' at right angles to the picture plane, draw a line from viewpoint O parallel to that line. The intersection point with the horizon is the required vanishing point V, which is coincident with distance point P.

L'V is the perspective construction of horizontal line L. All straight lines which intersect the picture plane at right angles have vanishing point V in common.

2. The vanishing point of a horizontal straight line L, which intersects the picture plane at a different angle, can be obtained by drawing a line OV from O, parallel to L.

Parallel horizontal straight lines which are not parallel to L (and do not intersect the picture plane at right angles) obviously have another vanishing point (V₂). If there is more than one vanishing point, then all vanishing points should be numbered.

3. Horizontal straight lines parallel to the picture plane have vanishing points in infinity and are therefore drawn parallel to the horizon.

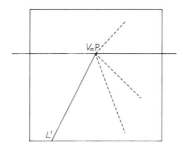

1

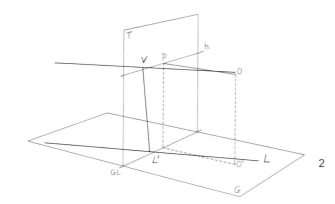

2

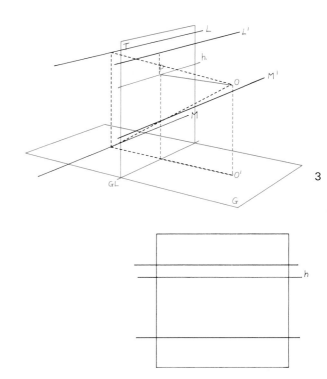

3

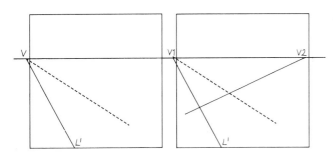

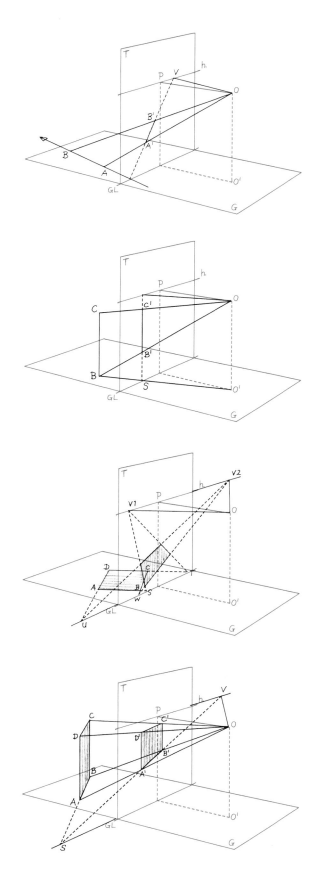

The perspective of a horizontal rod AB oriented in the ground plane

The perspective of a horizontal rod AB which lies in the ground plane can be obtained as follows:
Draw line OV parallel to AB. V is the vanishing point of the line of which rod AB is a part. Extend AB forward so that the line intersects the picture plane. Join the intersection point with the picture plane and the vanishing point. Draw sight lines OA and OB. A'B' is the perspective of rod AB.

The perspective of a line vertical to the ground plane can be obtained as follows:
Draw sight lines OB and OC. These lie in a vertical plane. On the section line of that plane with the picture plane we obtain B'C', the perspective of BC.

The perspective of a plane ABCD which is oriented in the ground plane can be obtained as follows:
Find the perspectives of the lines on which BA and CD are located by extending BA and CD to S and T respectively, the intersection points with the picture plane and by subsequently drawing a line from O parallel to BA and CD which intersects the horizon at V^1.
SV_1 and TV_1 are the required perspectives. Similarly, find VV_2 and WV_2, the perspectives of the lines on which AD and BC are respectively located. The perspective ABCD is the form which is generated between SV_1, TV_1, UV_2 and WV_2.

The perspective of a plane ABCD vertical to the ground plane can be obtained as follows:
Draw rod BA to intersection point S with the picture plane. The extension of rod BA intersects the picture plane at S.
Find vanishing point V of the line on which AB is located. SV is the perspective of this line.
The sight lines OA and OB intersect line SV at A' and B'. From A' and B' draw vertical lines which intersect sight lines OD and OC at D' and C' respectively.
Points A', B', C', and D' are the vertices of the required perspective of plane ABCD.

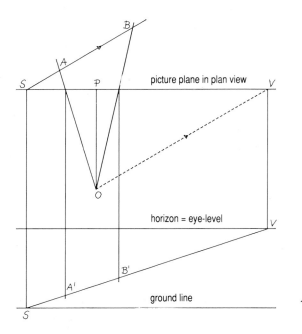

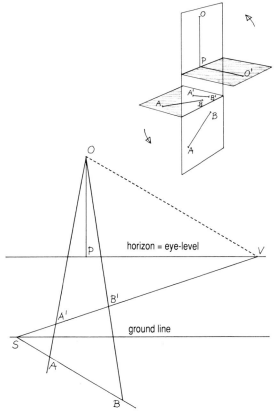

Several methods can be used to construct an accurate perspective on a flat surface of rod AB located on the ground plane. We will discuss three of these methods.

Method 1
Draw the situation in plan view. The picture plane, which is viewed from above, becomes a line. The distance OP is at right angles to the picture plane. The horizon and ground line are plotted at an arbitrary distance, below the diagram, in plan view. The respective distance depends on the horizon or eye-level. Draw sight lines OA and OB in plan view, extend AB to intersection point S with the picture plane and draw a line from O parallel to AB to meet the picture plane. V is the vanishing point on the horizon which lies on the picture plane seen in plan view.
Set up points S and V at right angles to the horizon and ground line respectively. SV is the perspective of the line on which points A and B will be generated. Project the intersection points of the sight lines with the picture plane perpendicular to points A' and B'. A'B' is the perspective of AB.

Method 2
The distance OP is folded over the horizon while the ground plane on which rod AB is located is folded downwards.
Draw line OV parallel to AB. Extend AB to points S to meet the ground line. Draw line VS and subsequently sight lines OA and OB. A'B' is the perspective of AB.

Method 3
This method differs from the previous two methods in that it uses a construction method which removes the difficulty of having vanishing points which lie far apart.
The method is based on the construction of a set of points in space which are then linked to give the required perspective. This method is surprisingly simple and efficient.

Overleaf an example is given of the perspective construction of a rectangle oriented in the ground plane (the plan of a small house).

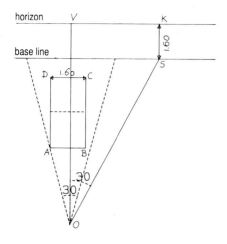

Choose the viewpoint O and restrict the visual angle to 30°. Then draw a base or ground line parallel to the breadth of the rectangle and an eye-level line/horizon line to scale. Actually, the rectangle is now located in front of the picture plane instead of behind the picture plane. On the horizon we obtain vanishing point V, which is the intersection point of the line through O perpendicular to the horizon.

Draw a line from O which makes an angle of 30° with OV and intersects the base line at S. (In principle any angle can be used, although usually an angle of 30° to 45° is chosen).

Then erect a perpendicular in S. The intersection point with the horizon generates construction point K.

Beware: construction point K can easily be confounded with the vanishing point of diagonal AC.

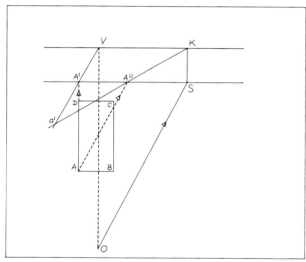

The following standard method is used to set up a perspective of any required point in the horizontal plane.

Draw rod AD to A', the intersection point with the ground line. Draw a line from V through A' and then draw a line from A parallel to OS which intersects the ground line at A". By drawing a line from K through A" we obtain perspective a' of point A on the extension of VA'.

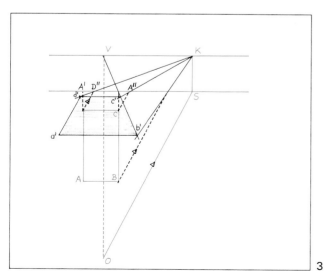

By using this standard method for the construction of the other vertices of the rectangle we obtain perspective a'b'c'd' of the given rectangle ABCD.

3

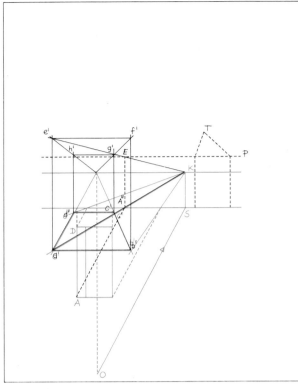

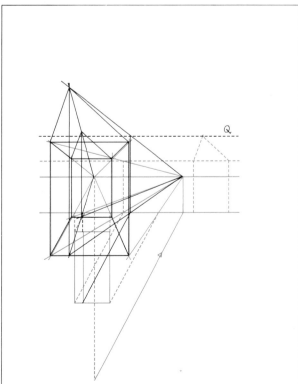

Similarly, the height in the perspective can be added by using this method. The elevation of a small house is placed on the ground line at an arbitrary distance but at the same scale as the plan. In the example, only the gutter and ridge heights are necessary in order to draw construction lines P and Q.

The gutter height can be obtained as follows: Draw line P through the gutter height of the elevation parallel to the ground line.

Erect a perpendicular in A" which intersects P at E. Extend line KE to intersect the erected perpendicular in a' at e'. Line Ve' intersects an erected perpendicular in d' at h'.

e'h' is the perspective of the first gutter.

By drawing lines through e' and h' parallel to the ground line and perpendicular to points b' and e' we obtain f' and g'.

f_1g_1 is the perspective of the second gutter.

To construct the perspective of the ridge of the house we have to repeat the previous process and draw auxiliary line Q through point T.

The third construction method is very simple. Actually, we can repeat a series of standard procedures. Because points instead of lines are constructed in space the construction of a single-point perspective does not differ from a two-point perspective. This method of perspective projection is known as 'two-point perspective' as it uses construction points instead of vanishing points.

horizon

Using perspective construction techniques discussed in method 1 on page 26 we can draw a simple architectural structure which consists of four cubes.

It is best to place the objects close to the picture plane, so that the perspective construction does not turn out too small and the required vanishing points are not too far apart. The drawing does not need any further explanation.

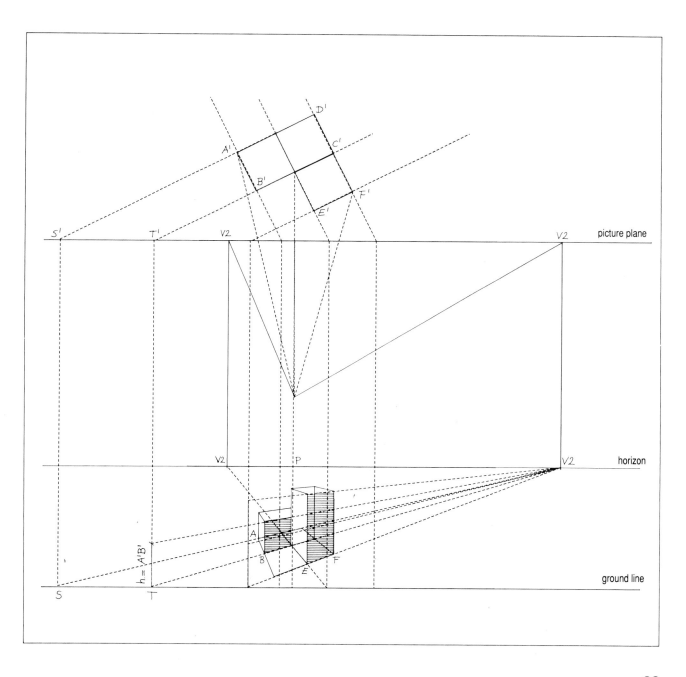

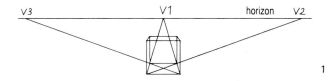

1

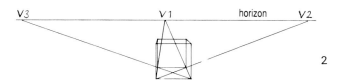

2

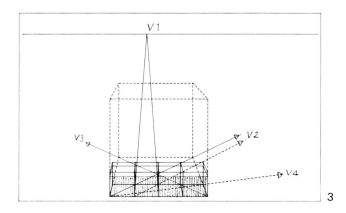

3

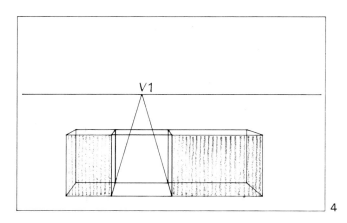

4

Single-point perspective projection

Single-point perspective is a common perspective projection method. One of the object faces is placed directly parallel to the picture plane and is not distorted. In the example this is the forward face of a cube. The vanishing point of the edges perpendicular to the frontal face is chosen behind the object on the horizon line.
Estimating the corresponding depth appears difficult in practice. Often the depth is overestimated. However there is a method for defining depth quite accurately, that is by using the diagonals of the bottom face. Care should be taken that the width of the object fits 5 to 6 times between the vanishing points of those diagonals.(1)
Vanishing point V1 can be marked exactly in the centre behind the object, however this is not necessary. (2)
If a long block, which is drawn in perspective, can be divided into smaller blocks then obviously these too are single-point perspective. But beware! The rule that the image width should fit 5 to 6 times between the vanishing points applies here as well. The image width of the beam is larger than that of the cube drawn above. The corresponding vanishing points of the diagonals of the beam and the cube are not the same. In order to view the entire block the viewing distance has to be larger. (3)
N.B. When we leave block a or block c of the large block in the drawing and imagine that the rest of the block has disappeared then we observe an error. If one represents a block at an angle then it is actually not possible to observe one face in unforeshortened position. In single-point perspective drawings this is not a problem. (4)

Vanishing point V_1 can be transferred as long as it remains within the image width. Through the transfer of the vanishing point in the street drawn on the facing page we obtain more information about either one street wall or the other. (5 + 6)

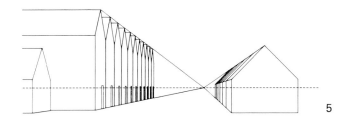

5

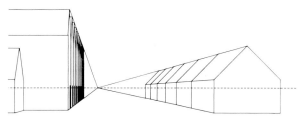

6

Sectional drawings in single-point perspective

Sectional drawings may appear quite complicated. They can be improved by showing the sectional views in perspective. First one draws the sectional view and then estimates the corresponding depth using the method discussed on page 30. With the aid of a three-dimensional grid (see page 32) the different sectional views can then be put in perspective.

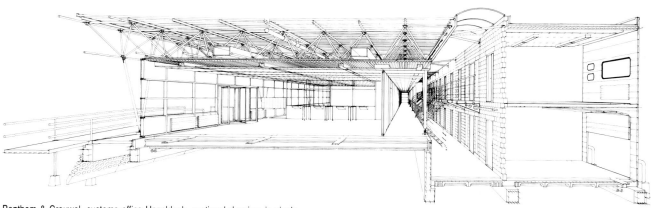

Benthem & Crouwel, customs office Hazeldonk, sectional drawing, in single-point perspective

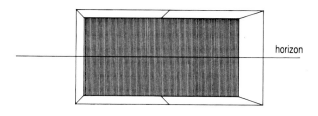

horizon

Interiors are often drawn in single-point perspective, to give a downward view when the ceiling plane is omitted or a frontal view when the front wall is left off. When we compare the two three-dimensional drawings – the first one in single-point perspective and the second in two-point perspective – we notice that the back wall and the floor are unfortunately concealed by a side wall. Certain parts will have to be drawn as if they are transparent and this makes it more difficult to read the drawing. The drawing in single-point perspective is in many respects preferable to the two-point perspective drawing.

The three-dimensional grid

A regular pattern of squares drawn in perspective is called a *three-dimensional grid*. The three-dimensional grid is an aid for the drawing an architectural or environment in perspective such that the drawing is visually convincing and the scene can be analysed.
The grid size is determined by the position of the viewpoint that the artist choses – a short or large spectator distance – and by the complexity of the subject matter.

A sectional view of a building is often based on a tile or pavement pattern. Such a tile pattern can determine the grid size.
The plan in the example is based on a tile pattern length of three metres. The corresponding heights can be inferred from the front elevation drawn at the same scale. The drawing of a grid of 3 x 3 squares for the example is based on the tile pattern size.

Step by step we shall set up bird's eye perspectives for the design on the left by using three-dimensional grids, first for a single-point perspective, then for a two-point perspective using a diagonal grid and finally for a two-point perspective based on a single-point perspective.
Lines which are not parallel to the grid lines can be found by subdividing the grid squares, so that a fairly reliable estimate can be made of the intersection points of these lines (or their extension) with the grid lines.

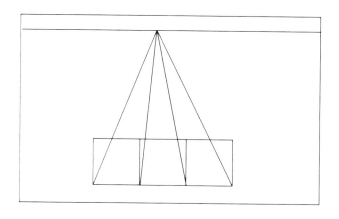

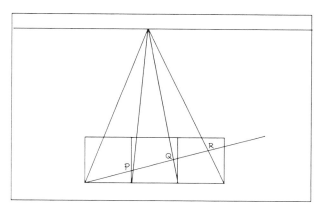

The single-point perspective grid

In a single-point perspective the forward plane is not foreshortened.

First draw three squares in frontal view and then define the horizon line. By placing the horizon line high in relation to the frontal plane the station point will also be high. This improves the organization of the drawing.

Then draw receding lines from the base points of the three squares to their vanishing point, which have been marked slightly to the left of the centre.

Define the depth of the total grid of 3 x 3 squares by using the diagonal of the entire plane.

N.B.: the image width has to fit 5 to 6 times between the vanishing points of the diagonals (see page 28). P, Q and R are vertices of the ground planes of three diagonally opposite cubes. Horizontal lines are drawn through these vertices. The three-dimensional grid of 3 x 3 squares has now been constructed. Complete the height constructions of the cubic grid.

Then draw the plan in the grid and finish the drawing by adding the correct heights starting with the forward, unforeshortened, plane.

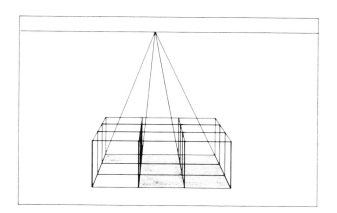

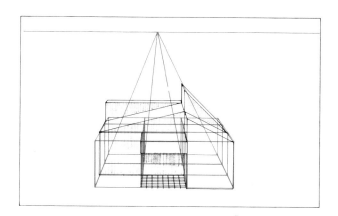

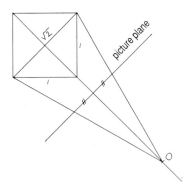

The diagonal grid

To construct a diagonal grid we can use a cube which has been drawn such that one of the two diagonal faces is set at right angles to the picture plane. The farthest vertical edge thus coincides partly with the nearest edge. The drawing on the facing page shows the cube and the spectator's viewpoint in plan view.

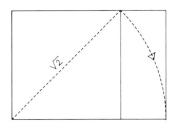

Given that the ratio of height to breadth of the unforeshortened diagonal plane is 1 to $\sqrt{2}$, we can construct this face according to the method described opposite. If this plan is divided in two then the front as well as the rear edge of the cube are located on this line. Select point A on the vertical line, the lowest point of the first vertical edge and then draw AB and EF, the bottom side and the top side of the right lateral face, respectively. The extensions of sides AB and EF should converge on a single vanishing point on the horizon line. The left lateral face can be drawn in the same manner.
If the horizon line has been drawn high, then the cube is seen from a high viewpoint.

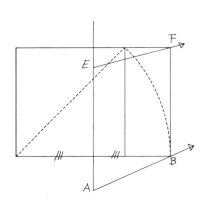

In order to complete the cube, lines are drawn from D and H to the common vanishing point of AB and EF and from B and F to the common vanishing point of AD and EH. The lowest point of the farthest edge, point C, then actually lies behind AE.

The three-dimensional grid is further developed by drawing a horizontal line through C in the ground plane and by extending AB and AD to meet that line. The rest is self-explanatory. The dotted line shows how the construction can be controlled.

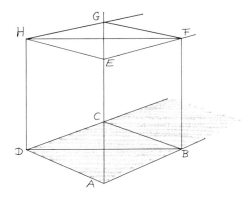

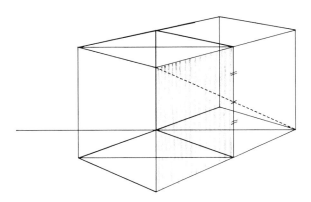

When the three-dimensional grid of 3 x 3 cubes has been completed, the floor plan and the heights are added.

The results of the different grids can be compared because their construction is always based on the same design. The disadvantage of the last grid is that a number of points lie exactly behind each other as a result of their symmetry. The grid however can be redrawn quite easily and by extending it to the left or the right the plan can be moved so that part of the natural setting can be introduced into the drawing which reduces its symmetry.

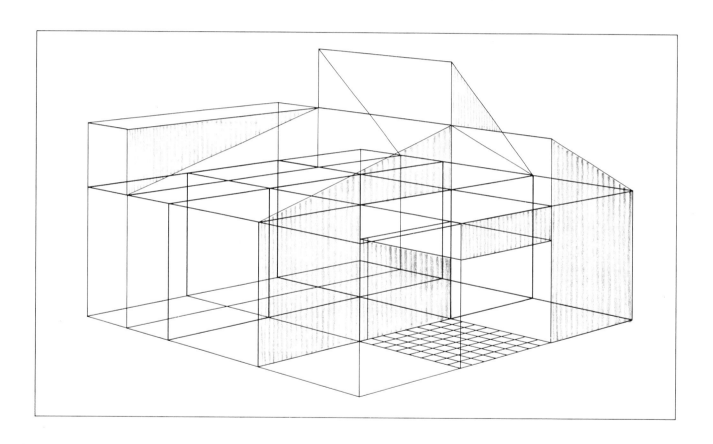

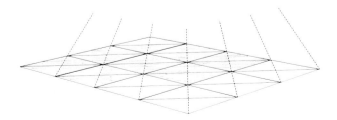
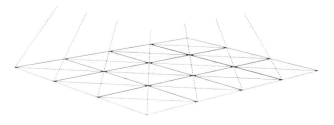

Bird's-eye and eye-level perspective in a combined drawing

Once a bird's-eye perspective has been drawn, then it is easy to set up an additional eye-level perspective. A necessary pre-condition is that the spectator's viewpoint should be changed in respect of the height, that is, the angle of incidence. Two drawings, in which the height of the station point varies, show the structural set-up – plan, layout, functional differences – and the three-dimensional effect of an object.

The auxiliary eye-level perspective of an architectural environment is used to study the proportional relationship between the buidings and the environment from a realistic viewpoint. The auxiliary eye-level perspective of an interior can be drawn based on the assumption of an interior view or – in the case of imaginary transparent walls – based on the assumption of an exterior view.

The principle of the combination drawing is shown opposite. The door serves as a clue to the scale of the drawn object. A dotted eye-level line is drawn on the door and side walls. This line could be drawn at eye-level around the entire building.

The dotted eye-level line of the bird's eye perspective in drawing 1 becomes the horizon of the eye-level perspective in drawing 2. Given the length of the vertical edge AC, parts AB and BC from drawing 1 are set out on drawing 2 respectively under and above the horizon. Similarly, the other vertical edges of drawing 1 are transposed onto drawing 2. The ridge height is extended in drawing 1 to the eye-level line and the extended rod is then placed above the horizon in drawing 2. The eye-level perspective is completed after the receding lines have been added.

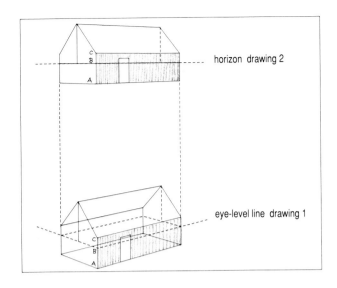

horizon drawing 2

eye-level line drawing 1

In order to save paper the horizon is moved in *eye-level perspective*. As illustrated below this reduces the distance between the two perspective drawings remarkably. Obviously, this does not affect the result of the eye-level perspective.

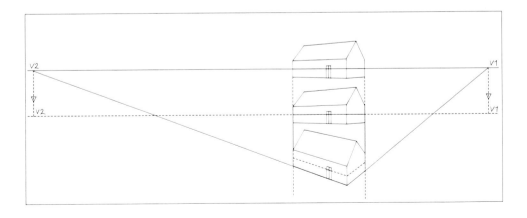

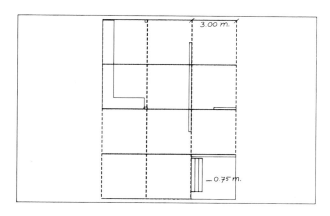

Example of a bird's-eye/eye-level perspective of an interior in single-point perspective

A viewpoint is chosen outside the interior in order to obtain a general view. The front wall is omitted or is imagined to be transparent.

Actually, the plan drawn in the cubic grid is adequate for the bird's eye perspective. The corresponding height can be introduced directly into the eye-level perspective. For reasons of clarity the 'props' have been omitted here.

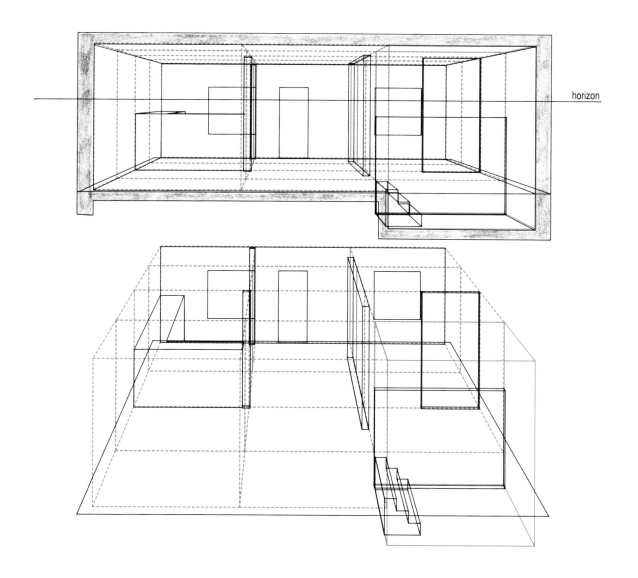

The single-point perspective grid as a
reference grid for the two-point perspective

A two-point perspective can be obtained with the aid of a single-point perspective grid by rotating the grid in relation to the plan.

The drawing of the house opposite illustrates this procedure. The grid squares are subdivided, so that more intersection points of the grid lines with the plan can be found. This allows for a fair estimate of the two-point perspective. An eye-level of 1.60 metres above level O is chosen.

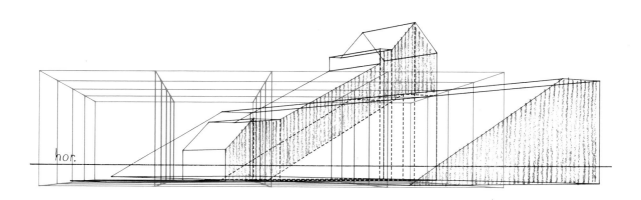

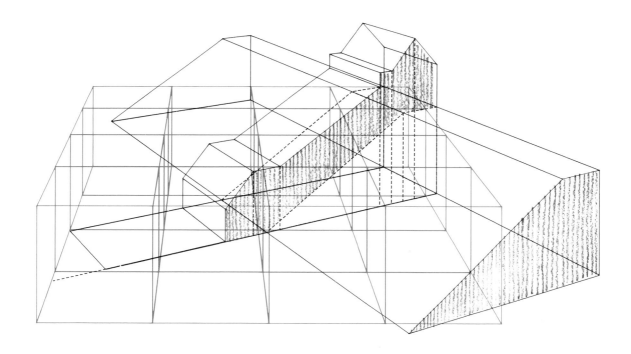

Freehand perspective drawing

Constructing perspectives using the radial projection method discussed in the previous chapter has its flaws:
- the method is very laborious;
- many auxiliary lines are needed which sometimes makes it difficult to recognize the image;
- perspective construction often becomes the sole object, whereas it should be the representation of a three-dimensional object or environment;
- working with tilted eye and ground planes results in standard and often misunderstood procedures which can spoil the pleasure of perspective drawing
- small inaccuracies often result in large distortions.

There are computer programs nowadays which under certain conditions can be used to produce perspective drawings based on the radial projection method, however the input of such data is time-consuming.

In this chapter we will examine a method of freehand drawing based on the *'cubic' method*. The cubic method is an approximate method and its aim is to represent a three-dimensional environment fast and efficiently. The freehand drawing skills necessary to draw cubes in perspective from every possible angle, also serve as a basis for producing accurate perspectives of the architectural environment. Freehand perspective drawing is outlined hereafter step by step with reference to the perspective theory discussed earlier.

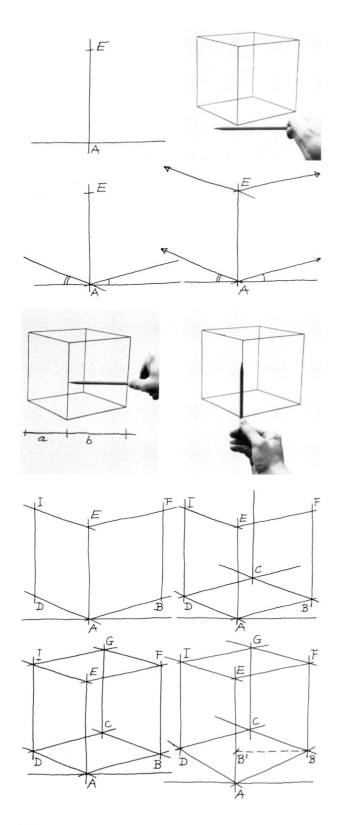

Drawing a cube by eye

Draw the foremost vertical edge AE. The length of this line determines the dimension of the cube to be drawn. A horizontal auxiliary line is drawn through A. By holding the drawing pen or pencil, horizontally so that the lowest point of the foremost edge of the cube is lined up with it, it is possible to estimate the angles which the lowest receding edges make with a horizontal line. These angles have to be produced as accurately as possible in the drawing. Given the heights of the horizon line – the horizontal line at eye-level – the two receding lines from point E are drawn into the direction of both vanishing points. Two infinitely large faces have been generated and the skill is to measure identical faces along the ones in the example. A preliminary sketch of lines BF and DI is made to determine whether they have been positioned exactly. This can be controlled by measuring the distances a and b in relation to the length of the foremost edge AE.

Measuring: the pen is held horizontally and perpendicular to the direct line of vision. The point should coincide with the foremost edge of the example and the thumb is used to move the pen until it is aligned with the right vertical edge. The dimension thus found is then compared with the foremost vertical edge. If the difference corresponds to that of the drawing, then line FB can be drawn in permanently. The same process is repeated to control the left lateral face. It is always more practical to measure the smaller dimensions along the larger dimensions.

Now draw lines from B and D to the common vanishing points with AD/EI and AB/EF respectively. The rearmost edge then lies on intersection point C. Rods FG and IG, which have been drawn to the correct vanishing points, complete the cube.

Often the angles at point A are overestimated. It is possible to control this in a simple way by projecting points B and D with the aid of horizontal auxiliary lines on AE. If the chosen angles are too wide then the projection points will be located too high on AE.

Constant practice is required to perfect freehand drawing skills that allow one to draw a cube from all angles without any effort. These skills can be carried through to the preparation of realistic three-dimensional drawings.

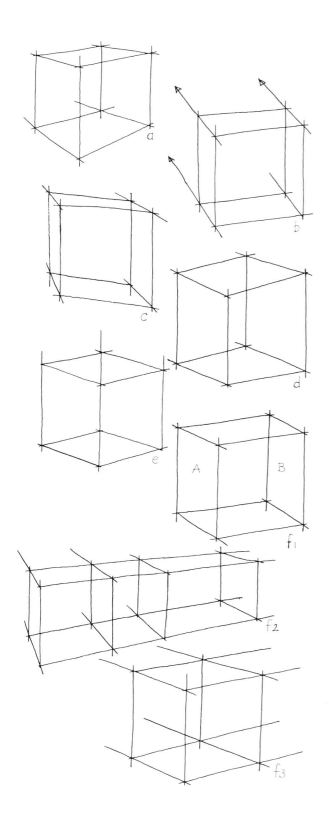

Frequent errors

It will be difficult in the beginning to judge the accuracy of a depicted cube. Some frequent errors are illustrated on the left.

drawing a
The vanishing points lie too close together. As a result of this the cube is distorted and shows the wide angle effect mentioned earlier. It is possible that the cube has been drawn from too close a viewpoint. The image width has to fit 5 to 6 times between the vanishing points.

drawing b
Here the receding lines converge on the vanishing points in both directions, however the vanishing points lie on an inclining horizon.

drawing c
A cube drawn at an angle always has a vanishing point on either side of the object on the horizon line. This is not the case in drawing c. This error is quite frequent when one of the lateral faces of the cube has not been sufficiently foreshortened.

drawing d
The parallel receding lines do not converge but diverge. Moreover, if a cube is viewed from above, then the top face is always flatter than the bottom face.

drawing e
This is an isometric drawing. The parallel receding lines run truly parallel instead of converging on the vanishing points on the horizon line.

drawing f
In drawing f_1 face A is revealed to view in contrast to the more remote face B. This should be the reverse in the case of a cube drawn at an angle. Drawing f_2 illustrates this. If the receding lines are further extended, then these errors are avoided; see drawing f_3. Correct convergence can be controlled much better in this way.

41

Cube and three-dimensional grid scale

It is not possible to determine by looking at a drawing of a cube whether it has sides of for instance 10 metres or 10 centimetres. A scale is therefore indispensable. A scale should also be used to indicate the chosen dimension of a three-dimensional grid.

The subdivision of grid squares

Base the drawing of a three-dimensional grid always on the largest cube possible. It is easier to divide a cube – this reduces the chance of possible errors – then to multiply the cube a number of times and run the risk that the grid becomes inaccurate. Dividing a cube should be done in the most prominent lateral face. A face, viewed from the side or from above, is less suitable because strong foreshortening can easily result in inaccuracies.

In the example, the vertical edges have literally been divided in two (see pages 20/21). The right lateral face has been divided using diagonals such that ground line AB is divided into four equal parts in perspective.

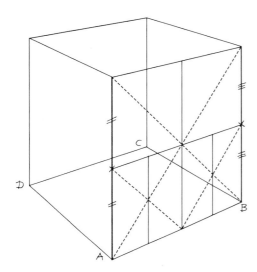

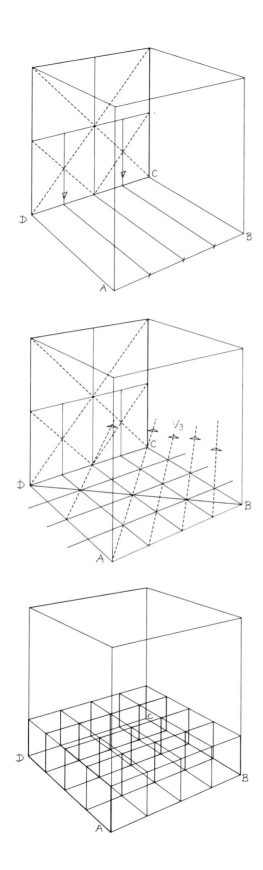

The rear face which is parallel to the right lateral face, is divided using the same method. The points located on line AB are joined with the corresponding points on line DC. The ground plane is further subdivided in a grid of 16 squares with the aid of diagonals. All lines parallel to AC have vanishing point V_3 on the horizon line. The diagonals serve to control the symmetry of the three-dimensional grid. The bottom row of cubes can now be drawn quite easily.

A perspective subdivision of ground line AB in the example into three, five or seven parts can be done according to the following simple method:
Divide the vertical sides of the square in three, five or seven parts and draw the connecting lines from the corresponding points. Next draw a diagonal and then draw vertical lines through its intersection points with the horizontal receding lines. The intersection points of the vertical lines with line AB produce the correct subdivision.

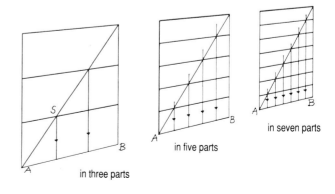

in three parts

in five parts

in seven parts

Constructing a two-point perspective using the cubic method

The same design as on page 32 is used to illustrate this method.

First draw a cube. The dimension of the cube is determined by the paper size and the required number of cubes. The example is based on a grid size equal to the tile pattern of the given plan. The vanishing points are positioned off the paper. However, their position should be taken into account. The lines in the direction of the vanishing points should be extended as far as possible.

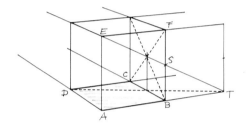

The lateral face ABFE is multiplied by placing point S in the centre of BF and by subsequently drawing a line from E through S which intersects the extension of AB at T. This method is explained on page 21. In order to control the construction, a line can be drawn from D through the perspective centre of BC, which should also meet T.

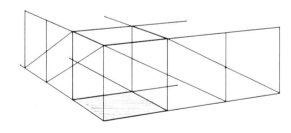

Both right and left lateral faces of the cube are multiplied three times. Make sure that the whole image fits amply between the vanishing points.

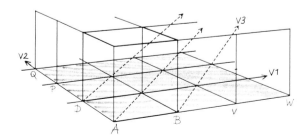

Lines are drawn from P and Q to vanishing point V_1; from V and W lines are drawn to vanishing point V_2. The diagonals in the ground plane can be used to control the construction. All diagonals should converge on vanishing point V_3.

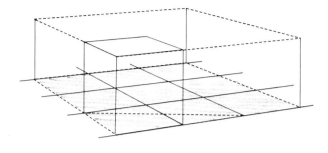

The ground grid, which has been set out on the basis of a 3-metre square tile pattern, is now completed. The corresponding height is the height of the cube. This height can of course either be extended over the entire grid plane or can be transferred to a rear face.

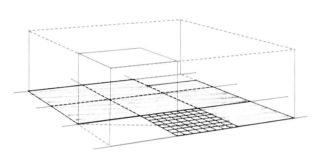

The three-dimensional grid serves as a reference grid for the given plan. According to the plan the tile pattern size should be subdivided in the furthest right-hand corner. The half-tile size is found by projecting the diagonals of the last square.

The perspective can be completed after the corresponding heights have been drawn in.

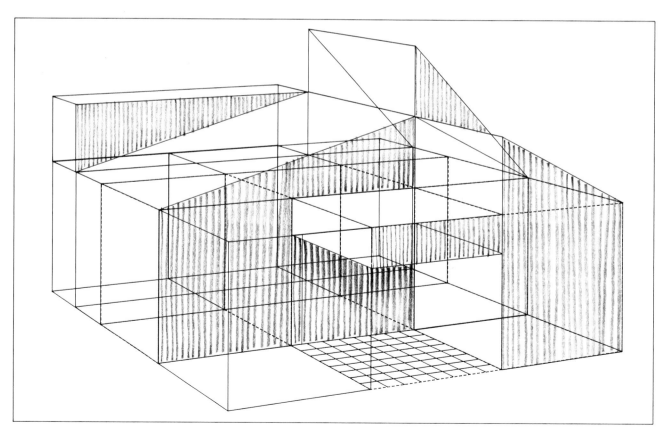

Using a three-dimensional grid

The use of a three-dimensional cubic grid is demonstrated in several simple examples which illustrate the following:
- an architectural environment in bird's-eye perspective;
- a bird's eye perspective of an interior which uses an exploded view;
- two combination drawings of a design for a building in bird's eye and eye-level perspective;
- a construction detail in perspective;
- a construction detail in exploded view.

An architectural setting in bird's-eye perspective

The grid size of the diagram and the corresponding front elevation is 6 metres. The highest building is thus 12 metres.
In this example the subdivision of the grid squares in the ground plane has been limited to 4 x 6 squares. The plan and its corresponding heights have subsequently been added to the grid.

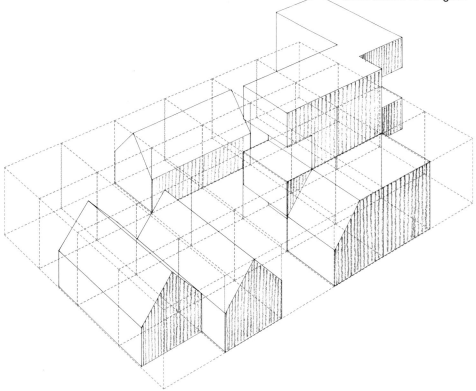

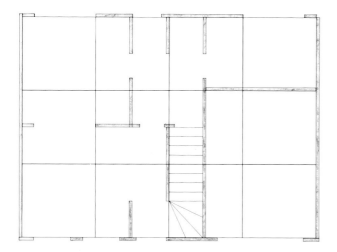

Bird's-eye perspective of an interior in exploded view

This is a special type of combination drawing. For the sake of clarity the detached parts are drawn in bird's-eye perspective and not in eye-level perspective.

Two horizontal ground planes A and B have been drawn at some distance from each other in the developed diagram on page 48. A 3-metre cubic grid has been chosen. The plan will be in ground plane A. Ground plane B is chosen as a level for the erect walls.

The exploded view is often used for the representation of complicated three-dimensional situations. The developed example on page 48 has been kept quite simple. First draw the bottom layer of cubes. The distance between both horizontal layers should be $1^{1}/_{2}$ or twice the height of the cube. In any case the distance between both faces should be chosen such that the walls do not overlap the diagram.

Both front faces have been omitted from the drawing for the sake of clarity.

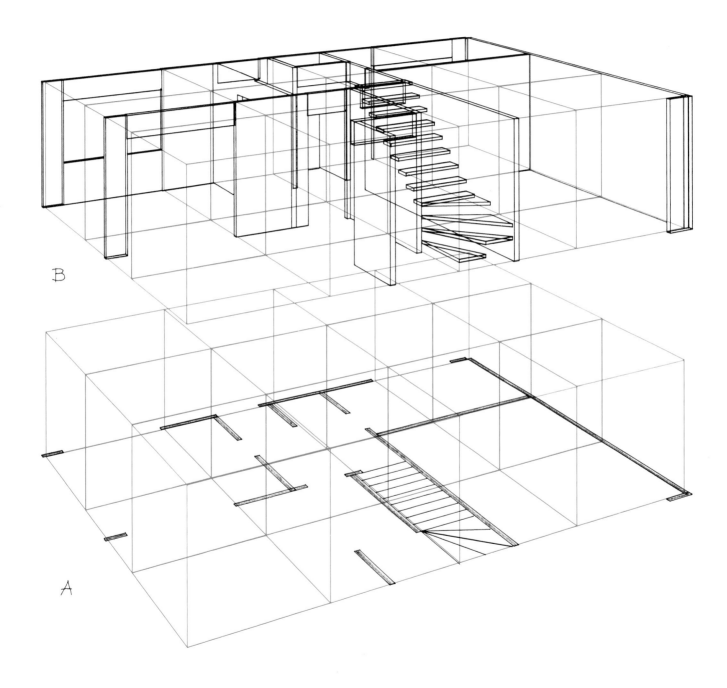

B

A

48

Combination drawing in bird's-eye and eye-level perspective

The chosen eye-level is 2 metres.
The next stage is now self-evident.

horizon

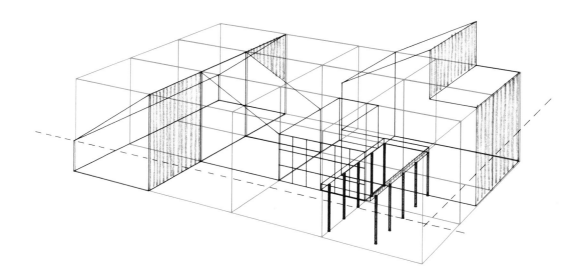

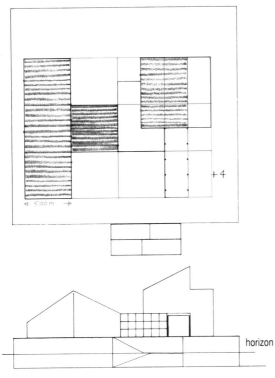

Combination drawing in bird's-eye and
eye-level perspective

The same building as on page 49 has been constructed, only the building is now located on a platform 4 metres high. The eye-level is 2 metres.

+ 4

← 5·00 m →

horizon

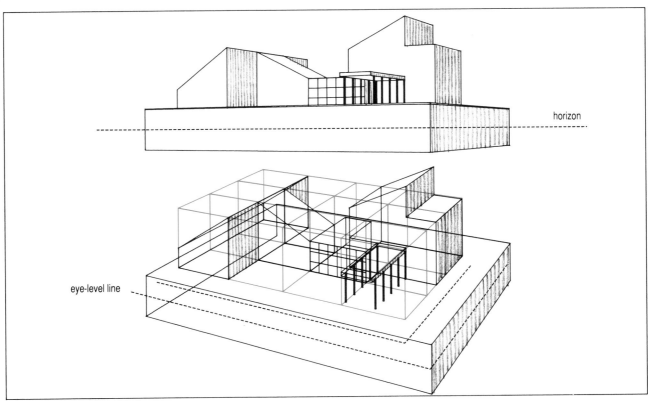

horizon

eye-level line

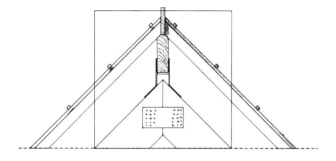

Construction detail in perspective

Certain construction details can be drawn in perspective quite easily on the basis of one single elevation. A detail of a roof construction has been drawn to illustrate this. The main rafters are drawn in one of the cube faces at an angle of 45°, that is parallel to the diagonals of the square. Subsequently, the other parts of the construction are drawn in the same face and its extension. The roof parts can then be drawn in perspective at right angles to the cube face in the next stages of the drawing.

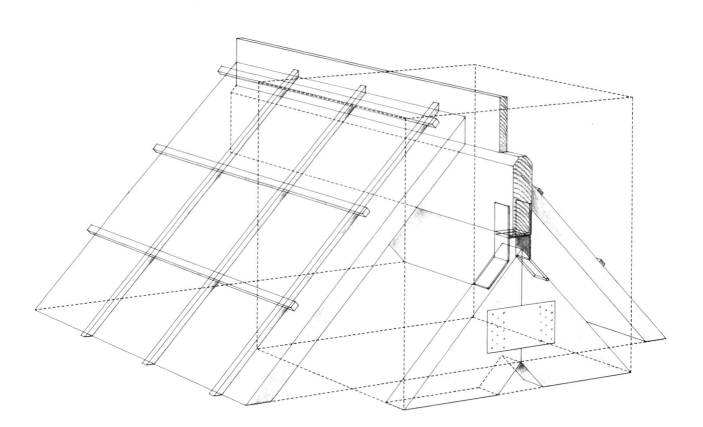

Construction detail in exploded view

The exploded view is mainly used for the representation of construction details to highlight the different components and their interrelationship.

A cubic grid is constructed such that there is little perspective foreshortening. Compare for instance the clarity of the two drawings of a timber-detail, below. Exaggerated perspective foreshortening causes problems (right), and information about the top face is almost completely lost.

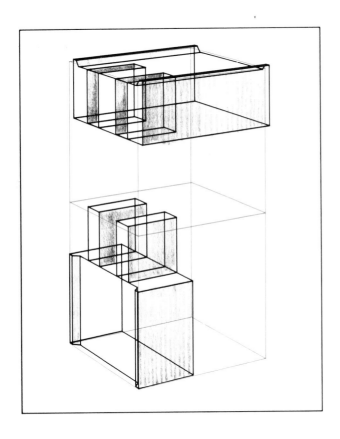

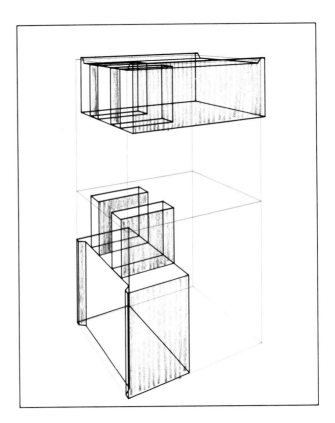

Using drawing paper with a pre-printed modular grid

The previous examples demonstrated the use of a cubic grid based on a freehand drawing of a cube. Using this method, it should be possible to draw a cube from every angle. There are also pre-printed perspective grids which can be used as reference grids. This book includes two grid papers in A3 format: one single-point perspective grid and one diagonal grid. Using such a reference grid it is possible to produce a realistic perspective drawing rapidly. It is possible to construct different perspectives of a single design dependent on the position and angle of the 'reference cube'. A different grid scale can be used if required, so that both urban spaces and interiors can bedrawn.

By using the method described on page 36 it is always possible to set up an eye-level perspective on the basis of a bird's eye perspective. It is therefore not necessary and even undesirable for reasons of complexity to use grid paper on which faces have been represented at different heights. The following grid drawing shows this clearly.

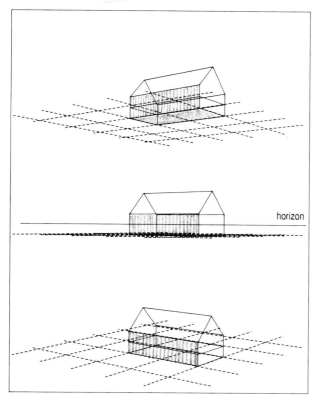

horizon

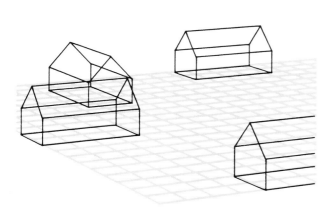

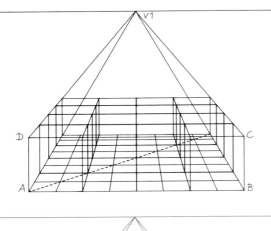

The single-point perspective grid

The grid construction is based on the image width AB, which fits approximately 4½ times between the vanishing points of the diagonals of the grid plane.

N.B. Always take the image width into account. When only a small part of the grid is used, the image width changes and produces a zoom lens effect. This gives an image of insufficient depth, in which case it is better to select a larger grid size.

Verticals BC and AD mark the ultimate boundary of the grid and the grid can only be used up to that boundary. Height AD is four times the breadth of the grid. The horizon has been placed as high as possible on the paper in order to obtain an organized grid.

The ground plane of a design has been indicated on the grid and the views are presented on the vertical walls of the 'box'. The bird's eye perspective can now easily be completed.

The diagonal grid

This grid has been constructed by using the method shown on page 34. If a square grid instead of a cubic grid is used as a reference grid, then the corresponding height of the cube can be found in a simple way by drawing diagonal AB of the first square. Set up a right angle from points A and B as shown on the drawing. Half of the square is now visible. Consequently, AC (=BC) is the height of the cube in points A and B.

Next draw the cube and complete the cubic grid.

To complete the drawing, the 'box' has been drawn again; the ground plane has been drawn on the bottom and the elevations have been added.

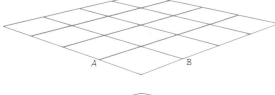

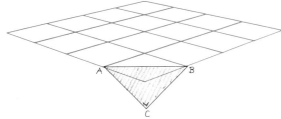

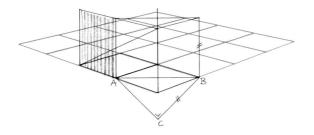

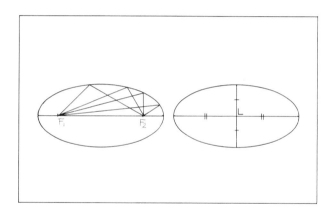

A circle in perspective

There are three different representations of a circle in space:
- a true circle, seen in elevation;
- a straight line when the circle is seen in plan view;
- an ellipse when seen from any other viewpoint.

An ellipse is a closed flat curve, where the sum of the distance between two fixed points F_1 and F_2 in the ellipse – the foci – is equal for each point. There are no circle rods in the ellipse.
The ellipse has two axes which are at right angles to each other and cut each other in half; the exact proportions are important in order to draw accurately.

Sketching a correct ellipse requires as much practice as drawing a cube freehand. It is possible to practice as follows:
Draw a square and place the tangent circle in the square. If we now draw the diagonals of the square we obtain 8 points of the circle which we can use to draw the ellipse, that is the 4 points of tangency to the square and the 4 intersection points with the diagonals.
Now draw a rectangle underneath the square whose breadth is equal to AB. This rectangle should serve as an aid for drawing the ellipse. Draw the diagonals in the rectangle and the two perpendicular axes of the ellipse. Extend EH and FG until they intersect the diagonals of the rectangle.
Eight points of the ellipse have now been located, that is the points of tangency to the rectangle and the intersection points with the diagonals. Now try to draw a 'tangle' of thin lines through these eight points with flowing movements. This tangle of lines will become ellipsoid and permit the construction of a correct ellipse in one single line. Start with the rods of the ellipse which touch the rectangle and subsequently add the missing parts.
The cross-hatched residual forms in the example should be identical or each other's mirror image.

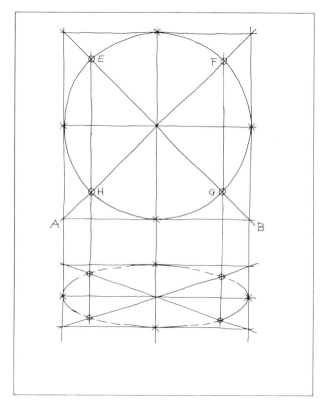

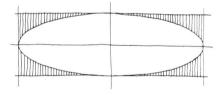

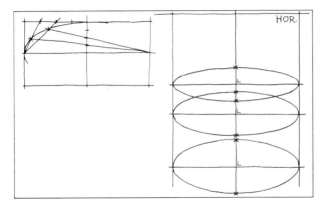

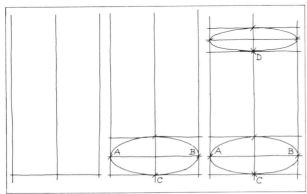

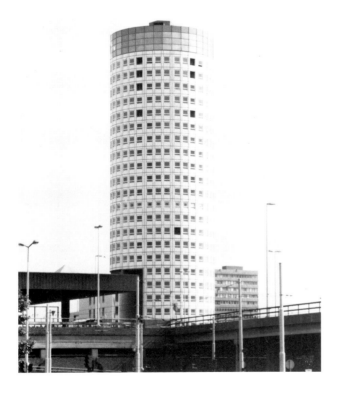

Of course it is possible to construct more points of the ellipse than the previous eight. The drawing opposite illustrates this.

However the construction of more points will eventually become superfluous after sufficient freehand drawing practice. In addition to drawing arbitrary ellipses the construction of a series of ellipses as illustrated in the drawing on the facing page is also recommended. These ellipses can be more or less flattened depending upon the chosen viewpoint on thehorizon. There are proportional differences between the major and the minor axes. Ellipses closer to the horizon are obviously flatter than ellipses which are further away.

A vertical cylinder in perspective

Following the exercise with the ellipse we can now draw a vertical cylinder. When drawing by eye it is necessary to visualize the proportional relationship between the ellipses of the bottom and top planes.

First draw the two outer verticals, the outer generators of the cylinder. The choice distance between the intermediate lines determines the dimension of the finished drawing. Add a horizontal auxiliary line and draw in the diameter. The latter represents the axis of rotation which is also known as *body axis* or *central axis*.

We will now need to define the proportional relationship between the major and minor axes of both the bottom and top planes. Using the metric method illustrated in the drawing of the cube on page 40.

Only the front rod of the bottom ellipse of a non-transparent cylinder is visible. The ellipse can be made visible by outlining the bottom with chalk and by moving the cylinder slightly. The height and the breadth of the ellipse can now be compared, so that these can be accurately introduced with the aid of an auxiliary rectangle. Return the cylinder to its original place and compare the breadth of the cylinder by measuring the distance between CD and AB.

N.B.: The height is measured from C and not from the less discernible points A or B.

Now draw the upper ellipse with the aid of an auxiliary rectangle, which is obviously not as high as the bottom ellipse because we see the cylinder in plan view.

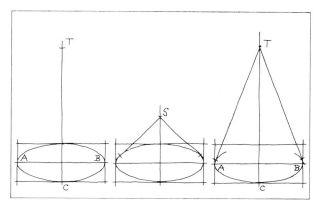

A vertical cone in perspective

First draw the ellipse of the bottom plane as for the vertical cylinder in the previous example. Remember to base the auxiliary rectangle on the correct proportion between the major and the minor axes. We obtain CT by measuring this distance and by comparing this distance with AB. From top T we then draw tangents to the ellipse. The points of tangency to the ellipse do not coincide with the extremities of the major axis as in the cylinder but they lie above the axis.

A horizontal cylinder in perspective

In the photograph of the church tower, left, we observe two circular clocks in perspective foreshortening. The ellipses in the vertical planes are diametrically opposite. This distortion is not arbitrary but follows a natural law. The major axis of the ellipse of the vertical cylinder is geometrically perpendicular to the axis of rotation. This rule also applies to horizontal and diagonal cylinders. The clocks constitute the end surfaces of the two intersecting cylinders. The detached cylinders are drawn in the following figure.

The drawing of an ellipse as end surface of a horizontal cylinder is further discussed on page 61.

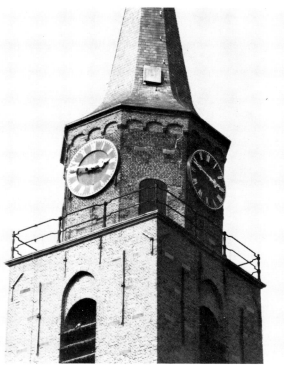

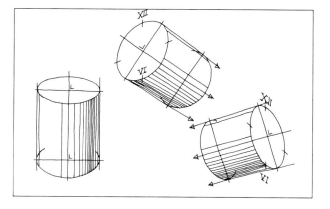

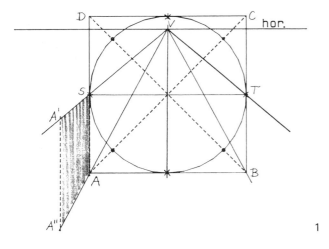

1

The perspective of a circle in a circumscribed
square

In order to place the perspective of a circle in its exact position in a three-dimensional grid we use a *circumscribed square,* that is a square whose sides touch the circle.

With the aid of a vertical circumscribed square, which is tilted as a pivot window in the horizontal plane, we now proceed step by step with the construction of the circle in perspective.

Draw a square vertical to the picture plane i.e., in elevation. The square is then tilted around axis ST in the horizontal plane, to give a single-point perspective. In order to tilt the square a horizon line is chosen between ST and DC on which vanishing point V is located as shown in drawing 1.

Draw lines VA, VS and VT from V and extend these lines forward. The tilted point A should fall on the extension of VS. By drawing the perspective foreshortened square A'SAA" we can place A' exactly. The square which has been tilted in the horizontal plane is generated in drawing 2 by drawing a line parallel to ST from A' until this line intersects the extension of VT at B' and subsequently by drawing diagonals from A' and B' through M which generate vertices C' and D' in the intersection points with VT and VS.

We now have to find the points of the circle that lies within the square. The four points of tangency to the tilted square do not present any problems. Also points E, F, G and H where the circle intersects with the diagonals of the square can easily be found in the tilted form in drawing 3. For that purpose join E to H and F to G and tilt these rods around points H" and G" of axis ST, by drawing lines VH" and VG" from vanishing point V and by extending these forward. We find four points of the tilted circle where these lines intersect with the diagonals of the tilted square. Drawing 4 illustrates this from a different angle.

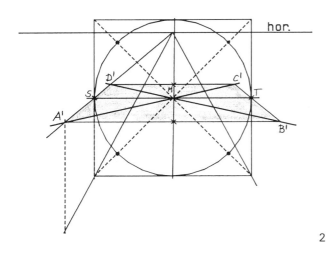

2

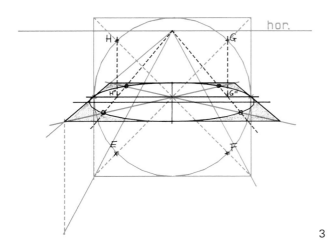

3

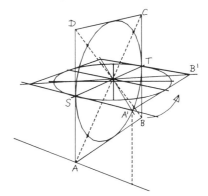

4

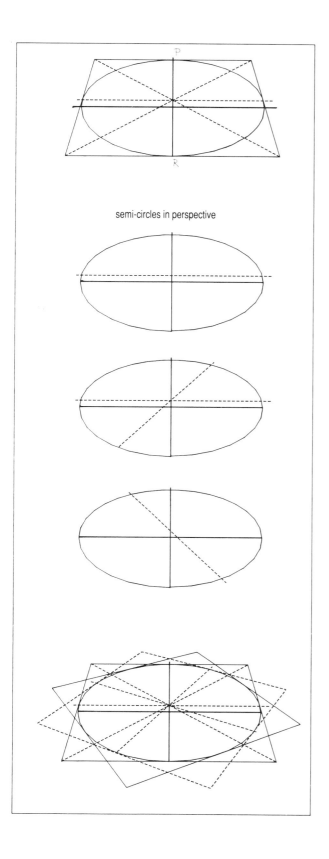

semi-circles in perspective

The major and minor axes of the ellipse can be added as follows. Divide the minor axis PR in two equal parts and draw the major axis through the centre, which is always at right angles to the minor axis and is moreover the longest possible straight line in the ellipse. The extremities of the major axis do not touch the vertical circumscribed square, but fall beyond it. The intersection point of the major and the minor axes does not coincide with the perspective centre of the square but lies in front of it. The three following drawings illustrate this phenomenon.

The shape of the ellipse can be drawn in one flowing line, taking into account the eight constructed points and the estimated positions of the end points of the major axis.

The ellipse is, as shown before, not only a geometrical figure but also a three-dimensional figure and can represent a circle in space. The perspective centre of a circle in space lies behind the centre – the intersection point of the major and minor axis – of the ellipse. The diameter of a circle in space passes through the *perspective* centre of the circle in space and not through the *geometrical* centre of the ellipse.

A horizontal circle in space is represented by a horizontal ellipse. The latter is not influenced by the position of the circumscribed square.

A vertical or diagonal circle is drawn as an ellipse when the position of the rotational axis determines the position of the major axis. We will discuss this further on page 61 together with semicircles in perspective.

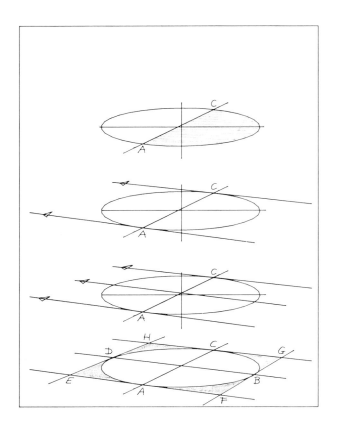

Drawing a horizontal square in a horizontal plane with the aid of an ellipse

If an ellipse can suggest a circle in space, then it is possible to use the ellipse as an auxiliary construction for the preparation of a true perspective square. The angle of view can be chosen at random. This creates the opportunity to prepare fast and accurate perspectives from any conceivable angle. The object rotates around an axis of rotation in space, so that all spatial aspects of the form can be studied.

Proceed as follows:

Draw an ellipse with the aid of a major and minor axis. Select a diameter which bisects the form in perspective. Draw two tangents through the intersection points of the diameter and ellipse, A and C. These tangents should obviously converge in the direction of their vanishing point. Then draw diameter BD, also in the direction of that vanishing point. Two tangents can now be drawn through B and D to the ellipse which in perspective are parallel to AC, that is, in the direction of their common vanishing point. EFGH then, is the circumscribed square of the horizontal circle in space. The 'reference cube' for the three-dimensional form to be drawn can be completed after the corresponding height has been chosen.

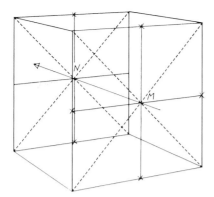

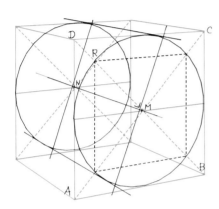

Drawing a circle in perspective in a vertical square

One of the lateral faces of a cube in perspective can serve as a visually realistic vertical square. With the aid of diagonals we obtain M and N, the centre points of two opposite squares. The major axis of the ellipse is at a geometrical right angle to the axis of rotation MN. The major axis determines the position of the ellipse. The drawing of the major axis through the perspective centre in a not noticeably foreshortened square is easy as the centre almost coincides with the centre of the ellipse.

Similarly, the four points where the circle touches the square are generated by point M. First a thumbnail sketch of the form of the ellipse is produced in pencil lines and then finalized. The intersection points of the ellipse and the diagonals of the square can also play a role in determining the exact form. The distance DR is somewhat smaller than a third of DM as shown in thedrawing of the square in elevation. Taking into account the perspective foreshortening of the diagonal we can project R in its exact position and transfer R to the other intersection points of the ellipse and the diagonals as shown by the dotted lines.

Drawing a circle in the strong foreshortened left lateral face of the cube can be done according to this method without drawing the major axis of the ellipse. The perspective centre of the square and the intersection point of both axes of the ellipse now lie further apart as a result of the strong foreshortening. The major axis of the ellipse is in this case placed in front of the perspective centre of the square.

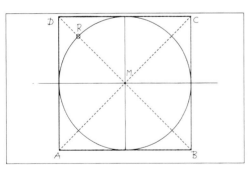

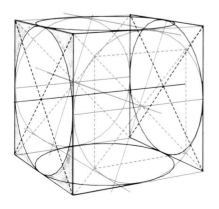

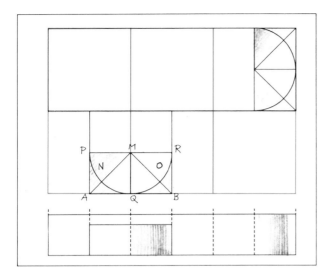

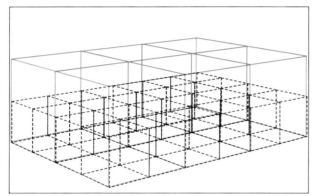

Circles and circle segments in perspective

Circle segments in a diagram

The upper diagram has been drawn at first in a grid of 2 x 3 squares. In order to define the circle rods accurately the grid has been divided such that the quarter-circles fit the square.

The perspective centre M of the circle as well as the tangent points P, Q and R are now known and can be transferred to the three-dimensional grid. With the aid of the tangent points we first make a thumbnail sketch of the ellipse. Because the rotational axis is vertical to the picture plane, the major axis is horizontal to the picture plane. First draw the least curved part PQ of the semi-ellipse and subsequently draw the semi-diagonals MA and MB of the circumscribed square. Intersection point N now has divided line MA at a ratio of 1 to approximately 3.5. From N a line is now drawn which in perspective is parallel to AB and which intersects MB at O. O is another point in the semi-ellipse and the latter can now easily be completed.

With the aid of the intersection points of the diagonals of the circumscribed square it is possible to draw the correct semi-ellipse. If this method is not followed, then the chances are that the surfaces of the residual forms will not be identical.

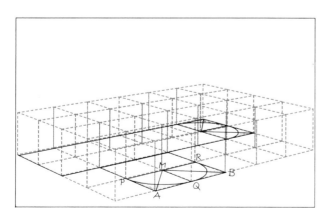

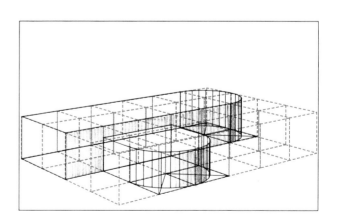

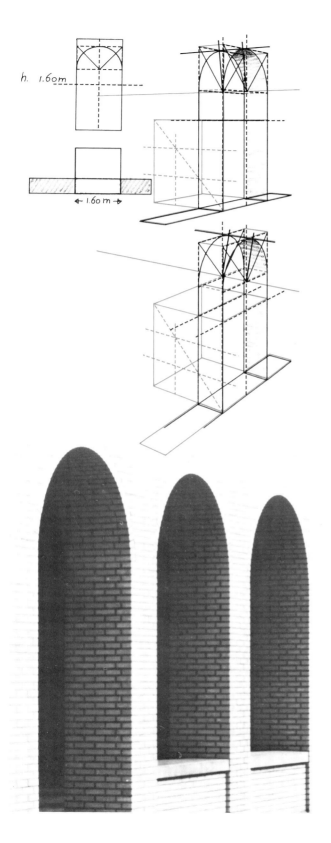

Circle rods in vertical walls

A gate has been chosen as example, first drawn in bird's-eye perspective and then in eye-level perspective. The changes in the position of the cube become apparent as a result of this.

Draw a cube and double the height in one face. Vertical measurements are not foreshortened as shown previously. As in the semicircle in the horizontal plane, the semi-square in perspective is used as an auxiliary square in the vertical plane. Keeping in mind that the major axis of the ellipse is at a right angle to the rotational axis, the semi-ellipse is now drawn in the auxiliary square. Roughly sketch the ellipse in thin pencil lines before drawing the definite form. Ensure that the semi-ellipse cuts the diagonals of the circumscribed square at the exact points.

A third of the edge size is chosen for the depth of the gate. For the rear face of the gate we can repeat the previous procedures. Add the outer generating lines of the cylinder wall and the drawing is finished.

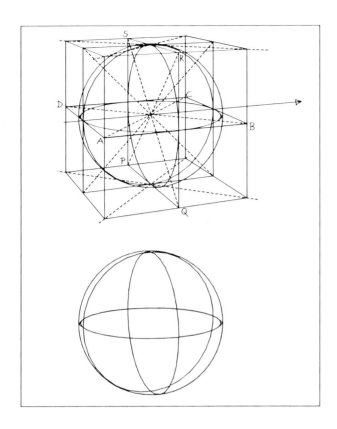

Some constructions using an ellipse

A sphere

A sphere in perspective is represented by a true circle. The highest and lowest point of the sphere can only be obtained by a constructive method.

The sphere is inscribed in a cube. In plane ABCD, the horizontal ellipse is drawn half-way up the height line in the customary manner. The ellipse has a horizontal major axis, which is simultaneously the diameter of the sphere. It is also possible to construct an ellipse in the vertical sectional plane PQRS. The rotational axis of the ellipse runs in parallel perspective to AB and DC and the major axis will have the same length as its counterpart in the horizontal ellipse in plane ABCD. The semi-major axis can be circumscribed into a sphere. The lowest point of the sphere is the point of intersection of the diagonals of the bottom face of the cube. The highest point in the upper face of the cube can be obtained in the same manner. If we imagine the sphere to be transparent, then the highest point will be visible and the lowest point invisible. In most cases the highest and the lowest point of the sphere will lie in perspective within the circumference of the sphere. One of the two points can be located on the circumference of the sphere, but never both simultaneously.

A spiral staircase

A spiral staircase can be drawn in the following manner: Draw the plan of the staircase. A quarter of the circle has been introduced into the example. The auxiliary cylinder is drawn above the plan.

N.B. The perspective centre of the circle in space does not coincide with the centre of the ellipse (see explanation on pages 58/59). For clarity the construction has been left out in the drawing on the facing page.

Because vertical lines are not foreshortened we can divide pivot AB in equal parts. The auxiliary ellipses which we are drawn at different heights become progressively flatter as a result of the changing angle of view. The points of intersection of the stairs and the circle from the plan can be simply transposed onto the respective auxiliary ellipses.

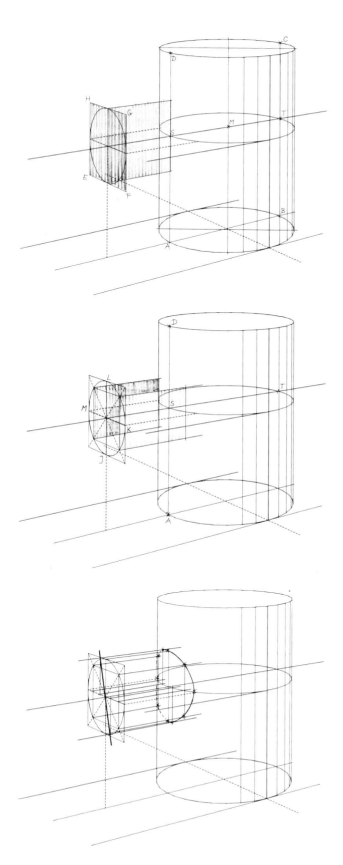

Two mutually perpendicular cylinders of different diameter

Draw a vertical cylinder. Select a diameter ST in a horizontal sectional plane. Plane ABCD bisects the cylinder. ST is the rotational axis of rotation of the cylinder with the smallest diameter. We now place square EFGH, which is in perspective at right angles with plane ABCD, on a point on the rotational axis. For this purpose we use the tangent in A, to which EF and GH run in perspective parallel. The intersection point of the two rotational axes is point M. Point S marks the place where the rotational axes of the small cylinder enters the large cylinder. Two lines can be drawn from L and J which run in perspective parallel to AB and which intersect line AD. The highest and the lowest point of the cutting plane have now been located. Lines can also be drawn from K and M which intersect the ellipse in which ST is located. The projected intersection points also are the two extreme points of the cutting plane, that is the nearest and the furthest from view. More points can be constructed as illustrated in the third figure. In order to obtain a reliable outline of the cutting plane, the intersection points of the extreme generating lines as well as those of the horizontal sectional plane have to be drawn.

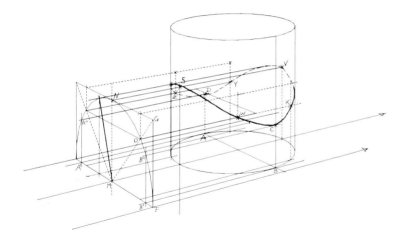

In the example opposite a cylinder with a smaller diameter is at right angles to the cylinder with a larger diameter. Draw both cylinders. Only half of the horizontal cylinder needs to be drawn. A'B' is measurement AB transposed onto EF. The vertical line from B' intersects the ellipse which is the end surface of the large cylinder in B". The line which is drawn from B" parallel to B'B produces point C perpendicular to B, the first of the two lowest points of the intersection. By using the inverse procedure CBAD we obtain the second point D. From N we again draw a line parallel to B'B. This line produces points S and V, the nearest and the furthest point of the auxiliary ellipse in the smaller cylinder.

Both points are the highest points of the cutting plane. In order to obtain the true form of the cutting plane we

Two cylinders of equal diameter which

converge at 90°

Again we make use of a circumscribed form – in this case a rectangle – to draw the cutting plane. The latter fits in the diagonal plane of the cube. Both cylinders are inscribed in a single form. It is important to always construct the transitional points between the extreme generating lines and the cutting plane. The two drawings below, drawn from different angles, show the result of the bisection.

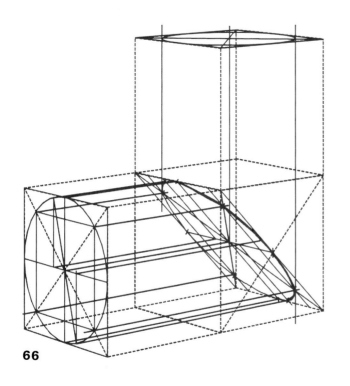

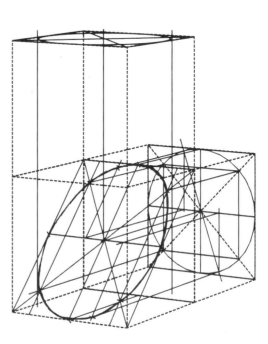

A torus

The following example shows the construction of a semi-torus. Draw a block which consists out of 2x4 cubes and transpose everything from the elevation onto the bottom and top face. We now obtain a semi-circular tube with a square cross-section.

Several cross-sections can be drawn in this figure. Corresponding ellipses are drawn for all cross-sections. The corresponding points of the different ellipses can be joined by way of further ellipses. It is then only a small step from the preliminary drawing to the final design.

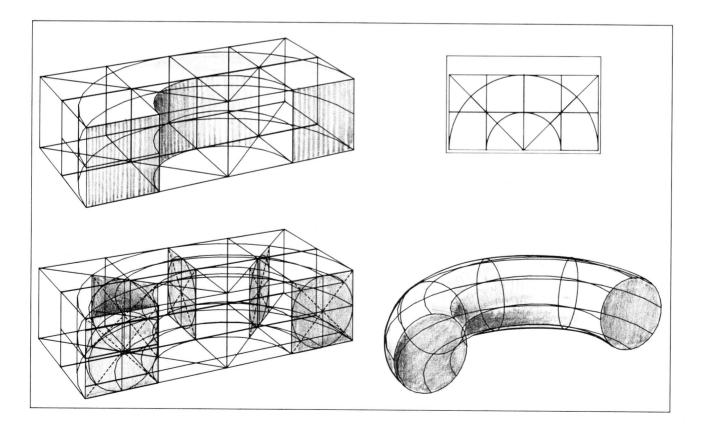

Regular polygons

Drawing regular polygons in perspective can be done quite easily with the aid of a circumscribed circle in space. An equilateral triangle is drawn by tracing a diameter and by bisecting the radius and then by drawing line AB through intersection point S, which runs in perspective parallel to the tangent in R. AB, AT and BT are the sides of the equilateral triangle.

The extensions of lines AM, BM and TM generate the remaining vertices of the regular hexagon.

A regular pentagon can be obtained by dividing one half of the diameter of an ellipse in perspective in four parts and by dividing the other half in three parts. Lines can be drawn through points A and B which run in perspective parallel to the tangent in R. The method used in this case is only an approximate construction.

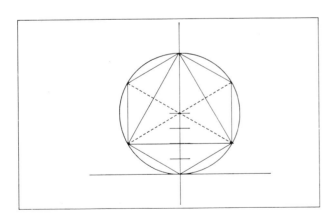

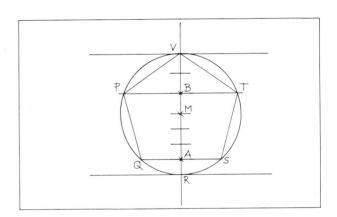

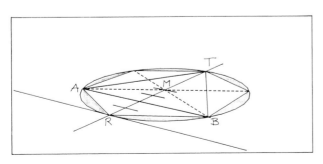

An arbitary, single curved plane

An arbitrary single curve can be drawn in perspective by placing a grid over the curve and by subsequently drawing the grid in perspective, as illustrated in the example below. The different intersection and tangent points to the curve can be transposed onto this grid. The degree of accuracy depends on the intricate pattern of the grid. We can now construct the curved plane on the basis of the curved line.

Multiple curved planes

We can draw multiple complex planes with the aid of cutting planes taken in one or two directions within a cubic grid. The inclined plane in the example has been obtained by first drawing the cross-section in one direction and then the cross-section in the other direction.

Body shadow, cast shadow and tone

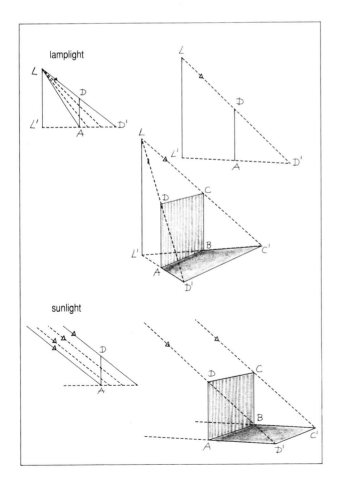

Light rays projected on a three-dimensional form will illuminate certain parts and project shadows on other parts. The shadow cast on the sides of an object excluded from light is known as the *body*.

The illuminated form also casts a shadow on the objects in its environment, such as a ground plane, a wall or a neighbouring object. This is called a *cast shadow*.

The incident light causes tonal graduation. Adding tone to a drawing enhances the life-like quality of the drawn objects and makes it easier to read the drawing. From looking at examples around us we can see that strong lighting will result in stronger light-dark contrasts for instance than soft lighting, while, given the same amount of lighting, smooth and rough surfaces will differ in tone and the shadow side of an object can be influenced by the reflecting environment.

In this chapter we examine the construction of body and cast shadows. Where necessary, a schematic diagram is presented in plan in addition to the perspective drawing.

To construct the perspective shadow projection of shadows we must know the direction of the light and the incident angle of light rays with the horizontal ground plane. Drawing the shadow of object AD, located in a horizontal plane, illustrates this in plan and in a three-dimensional drawing. Two different light sources can be distinguished:
- one which projects *diverging* rays (single source light, artificial light);
- one which projects *parallel* rays (sunlight).

When light rays are projected from an artificial light source near to the object, the light rays are considered not to be parallel. Because of the large distance between the sun and the earth, the sun's rays can be considered parallel. The difference in construction is explained by the examples of a cast shadow of a vertical wall. Plane ABCD, illuminated by an artificial light source, projects the cast shadow ABC'D' which is obtained by extending LD and LC, and by joining L' (the projection of L on the ground plane) to A and B and by projecting L'A and L'B to intersect with the light rays in D' and C' respectively.

A cast shadow projected by sunlight can be found in the same manner except that the projected light rays – in

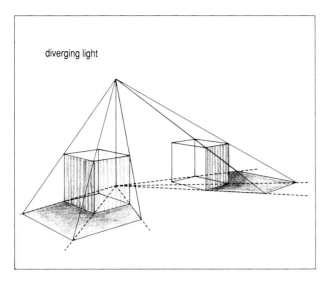

diverging light

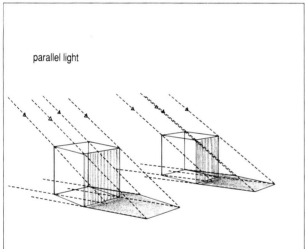

parallel light

contrast to L'D' and L'C' in the first drawing – now run in perspective parallel.

The difference between shadows cast by artificial light and by sunlight is illustrated by drawing two parallel blocks with their corresponding shadows. Single source light causes two non-identical cast shadows. A block close to the artificial light source projects a short cast shadow on the plane of projection, whereas a more remote block projects a longer shadow. Sunlight, on the other hand, projects identical cast shadows. An obvious preference is therefore given to projection by parallel light rays (sunlight) for rendering buildings. For this reason, the construction of cast shadows generated by artificial lighting is not discussed in this book.

To construct shadows cast by the sun the procedure outllined above for the construction of shadows on a vertical object AB is used; the procedure is repeated twice for a wall and three times for a rectangular block. The light rays and their projections on the ground plane should be in perspective parallel.

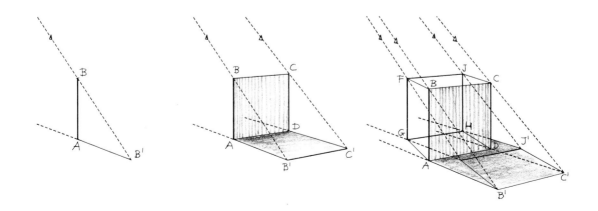

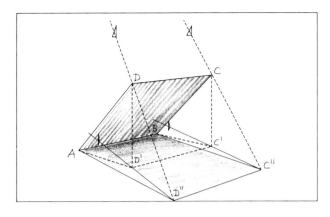

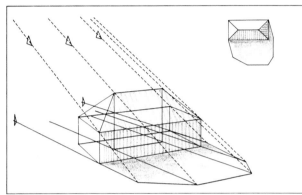

The shadow cast by an inclined plane

The angle of inclination for the inclined plane ABCD is defined by triangle ADD'. D' is the projection of D on the ground plane. Draw a light ray through D and the projection of the direction of light through D'. The cast shadow of D comes at the point D" on the ground plane. The cast shadow C" is obtained by the same method. AD" and BC" are the respective shadows cast by the inclining edges AD and BC. AD"C"B is the shadow cast by plane ABCD.

A common shadow construction, based on the above method, is shown, left, to illustrate this method. The corresponding plan view has been added to the perspective. To draw the shadows of the roof surfaces, it is important that the extremities of the ridge are projected on the ground plane.

The shadow cast by a suspended block

The illusion of a suspended block can be created by drawing its shadow cast on the ground plane. The method is as follows:
Draw a block and define the distance between the bottom of the block and the ground plane. In the example this distance equals the height of the block. We draw the light ray through E and its projection through A'. The inclination and the direction of the light ray are now known. The shadow of E falls in E' and the shadow of A in A". A"E' is the shadow of the vertical edge AE. The shadows of the other vertical edges are constructed by the same method. Completing the shadow cast by the suspended block is now straightforward.

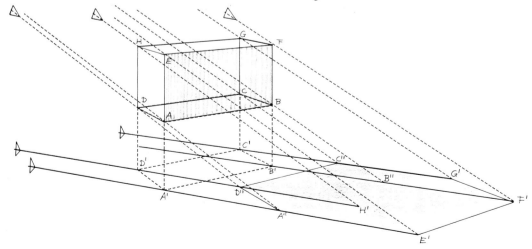

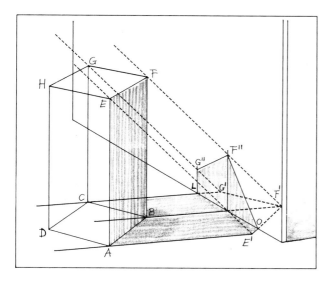

The shadow cast by a vertical block in a vertical plane

We first construct the shadow cast on the ground plane; then the vertical plane is introduced. The light rays FF' and GG' intersect the vertical plane in F" and G". G"F" is the shadow cast by the edge GF on the vertical plane. The cast shadow of the edge GC meets the vertical plane at L and curves into the direction of G". A similar phenomenon occurs with the shadow cast by EF. This cast shadow meets the vertical plane at O and curves into the direction of F". The block's cast shadow, which is projected on the ground plane as well as the vertical plane, is constructed by the connection lines of points A, E', O, F", G", L and C.

The shadow cast by a block on an object

Again we ignore the house-shaped object and first draw the cast shadow of the large block on the ground plane, subsequently introducing the second object.

The bottom drawing illustrates how the cast shadows of the two vertical rods AE and AX are build up on the house. The hatched part is the cutting plane through the house, generated by a vertical plane, which is imagined through AE and AE'. When we ignore the little house, AE' is the cast shadow of AE on the ground plane and AX' that of AX. AOPE" is the cast shadow of AE on the ground plane as well as on the house and AOX" is the shadow cast by AX.

By this method the cast shadow of one block which projects onto another object can be constructed. The cast shadow on the ground plane completes the drawing.

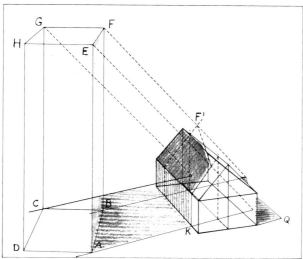

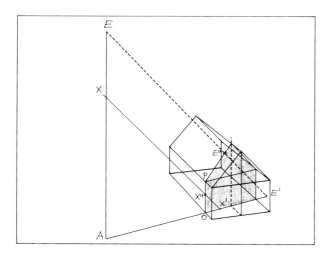

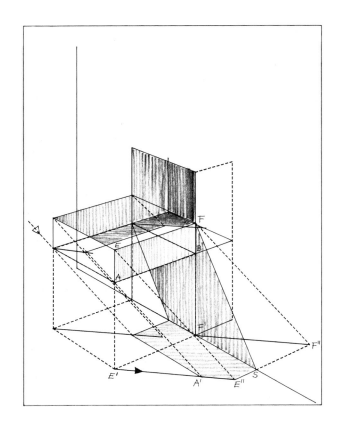

The shadow cast by a partly recessed balcony

The shadow construction of the balcony can be compared with that of the suspended block combined with the shadow construction of the block on a vertical plane. The 'rear wall' of the protruding part of the block coincides with the vertical plane and therefore cannot project any shadow on the plane of projection. The shadow cast by line EF is then obtained by joining E" and F" and by subsequently drawing rod SF from breaking point S. E"S and SF jointly form the shadow cast by EF.

The recessed part of the balcony does not reveal any details of the shadow construction.

The shadow cast by an overhang

First construct the shadow cast by the block-shaped lower part of the form on the ground plane. The shadow cast by edge KL of the prism horizontal to the block can be obtained by projecting K and L on the ground plane and by subsequently constructing the cast shadow K" and L" on the ground plane. In order to determine the direction of the cast shadow KL on plane ABFE this plane should be extended forward (see dotted line).

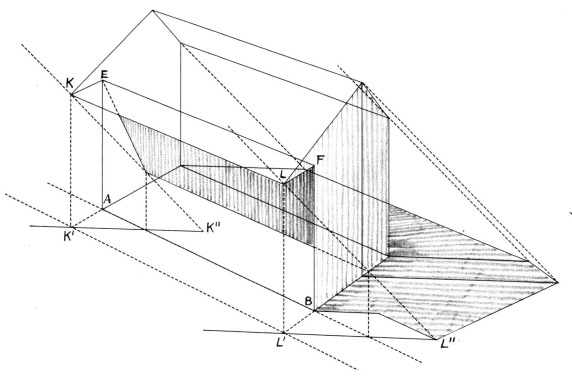

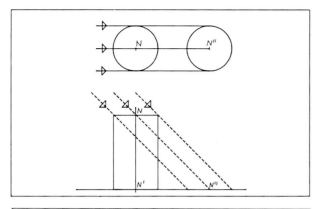

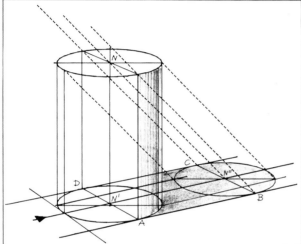

The cast shadow and body shadow boundary of a vertical cylinder

The circular top plane casts a circular shadow on the ground plane as illustrated by the elevational drawings. The shadow cast by the circle is positioned by the shadow cast by midpoint N. In order to construct these shadows in perspective projection it is essential that the ellipse which represents the cast shadow is more convex than the top plane of the cylinder and also smaller because it is more remote. The tangents AB and CD which connect the shadow cast by the top plane with the base of the cylinder complete the shadow cast by the former. The body shadow of the cylinder extends from point A to point D.

The cast shadow and body shadow boundary of a vertical cone

Draw T" the shadow cast by top T. The shadow cast by the cone is obtained by drawing tangents from T" to the base ellipse. The body shadow again extends from point A to point B.

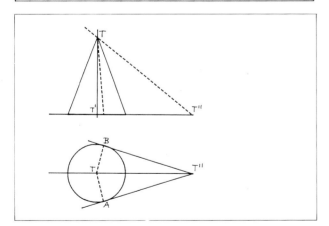

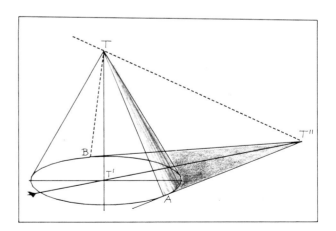

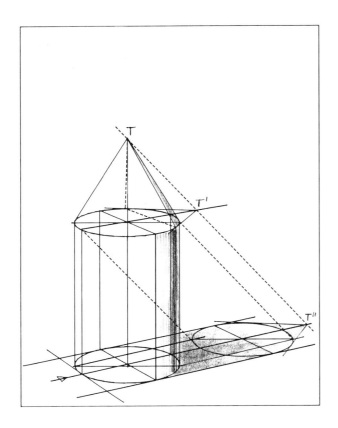

A stacked cylinder and cone

1. where a cylinder and cone have bases of the same diameter

The combination of a cylinder and a cone on the facing page shows the difference in the shadow boundaries of the individual parts. A larger part of the cone will be illuminated than that of the cylinder. The body shadow boundary of the cylinder is determined by tangents to the cylinder base, which run in perspective parallel to the shadow of the rotational axis, while the tangents converge on one point with the shadow of the apex at the cone base (see page 75).

A cylinder stacked on a cone

2. where the diameter of the base of the cone is larger than the diameter of the cylinder

The body shadow boundaries change here as well, however the cone base casts a shadow on both the ground plane and also on the cylinder. This cast shadow can be constructed by determining the shadow of a number of points of the cone base and by joining these shadow points in a flowing line. Another faster method is as follows:

Draw the projection of the light rays on the ground plane on which the cone base sits and proceed according to the drawing.

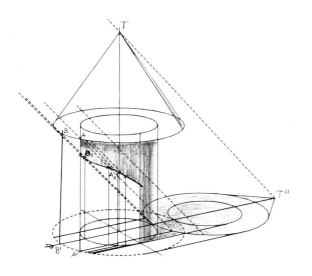

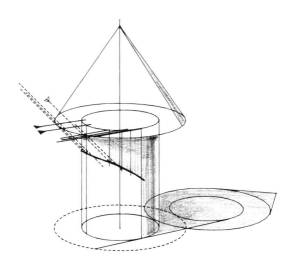

A cylinder stacked on a truncated cone

In this combined figure the body shadow boundaries change as well and the cylinder casts a shadow on both the ground plane and the truncated cone. The construction of this last shadow requires a certain degree of spatial interpretation. The cylinder, on which the body shadow boundary is shown, is extended to the ground plane. SV, the tangent to the base of the extended cylinder is drawn to the point where the extended body shadow boundary meets the ground plane. This tangent is the ground line of a vertical sectional plane through the cone. It follows the direction of light and meets the cylinder in its body shadow boundary. The conic section in question is constructed by drawing rays from the centre M' in the ground plane, which intersect the ground line SV and the cone base.

Perpendiculars are erected on the intersection points with the ground line. Generating lines are drawn from the intersection points and the cone base to the apex of the cone. The intersection points of these lines and the perpendiculars on the ground line are the points of the conic section. See the bottom drawing for construction. The part of the conic section from the cylinder's body shadow boundary stacked on the truncated cone is the boundary of the required cast shadow on the cone. As illustrated, the body shadow and cast shadow do not flow into each other but are at an angle.

A sphere

On page 64 we show how a sphere is constructed with the aid of a cube. The cube is used again as a reference cube for the determining shadows. The light rays are drawn at an angle of 45° with the ground plane and the direction of light is parallel to one of the edges of the cube. The sphere's body shadow boundary will be projected on the diagonal plane ABFG as a result of this choice. The light rays run parallel to EC and HD. Two points of the shadow figure coincide with C and D as a result. By drawing a vertical sectional plane parallel to BCFE in the centre of the sphere, we can let the incident light rays touch this sectional plane in points S and T at an angle of 45°, which produces shadow points S' and T', the nearest and furthest points of the shadow ellipse respectively.

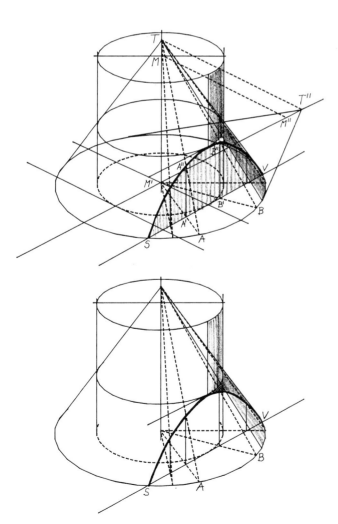

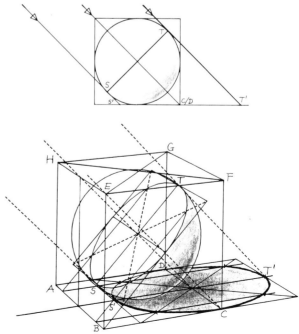

77

A hollow cylinder

On page 75 we explain how the body shadow boundary and shadow cast by a cylinder are constructed. On the inside of a hollow cylinder a body shadow as well as a cast shadow is projected. The cast shadow starts on the inside of a hollow cylinder where it terminates on the outside of the cylinder. The cast shadow of point A is projected on the inside of the cylinder on A". It is easy to find the cast shadow from a number of other random points (B, C, D). The cast shadow boundary will be the part of the ellipse which originates in points P and Q and which touches the generating lines of the cylinder on the right. A small part of the cast shadow is revealed in view to the right under point Q.

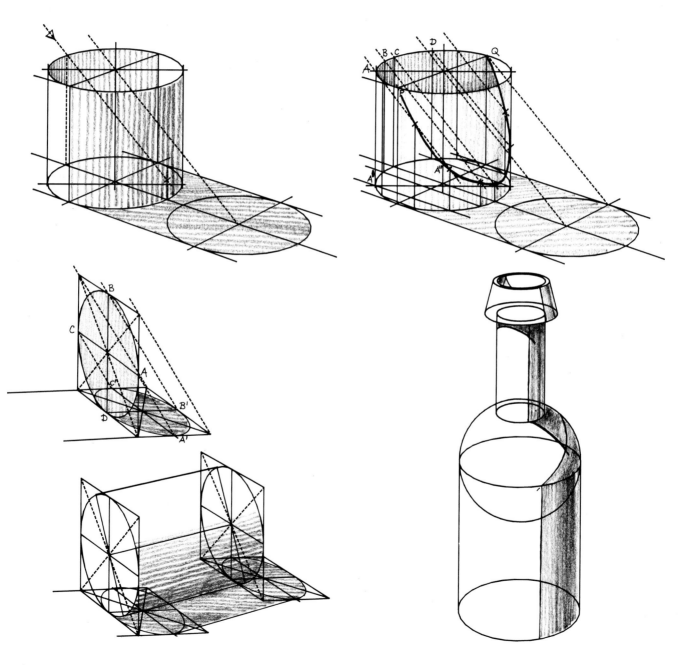

A horizontal cylinder

A vertical cylinder produces a diagonal ellipse as cast shadow. It is possible to determine the location and form of the shadow with the aid of a circumscribed square. To construct a horizontal cylinder we have to repeat the procedure twice, see page 78, bottom left.

The body shadow boundary of a combined form

The body shadow boundary on the bottle shape on page 78 has been sketched in broad outline. The body shadow boundary will not run parallel to the circumference, but depends on the incident light rays projected on the different parts.

Tonal study

The previous examples of shadow construction intended primarily to illustrate the form of particular shadows. A thorough understanding of the concept of shadow construction can help to lend an element of realism to two-dimensional perspective drawings. By looking around us we can see that illuminated shapes have a range of tonal gradations. The degree of lighting, the surface texture of the objects as well as the environment play a crucial role. Accurately rendered tonal studies can contribute to the illusion of reality.

An example of such a tonal study is shown below. The illusion of rotundity is best when the highest lights – the highlights – and the darkest tones have not been applied not to the circumference but towards the centre of the shape. This is a more accurate rendering of a reflecting environment.

Progressive tonal gradation seems to contradict the results obtained from the construction of the body shadow boundary, but this is of course true. The part of the object which receives the incident light rays from an acute angle will be the lightest in tone because the reflection on that area is the strongest. The angle of incidence changes gradually for a round object, which explains tonal gradation.

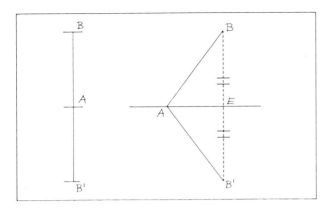

Reflection

Smooth surfaces of objects reflect light and also reflect the environment. The exact proportion of reflection is explained as follows.

A horizontal reflecting plane

When a vertical object AB is placed in a reflecting plane, its mirror image A'B' is equal to AB. If the object AB is at an angle to the reflecting plane, then B should be projected on the surface and subsequently the projecting rod BE should be doubled to obtain the mirror image A'B' of AB. Blocks P and Q are reflected according to this principle.

Block R is located on a shiny but not entirely reflecting surface. A reflection as well as a cast shadow result. The area where reflection and cast shadow overlap becomes darker in tone.

Block S is placed on a mirror. This mirror consists of a glass plate, to the bottom of which a reflective material has been applied. The distance between the block and the reflecting plane is determined by the thickness of the glass plate. The block appears to be suspended.
A cast shadow projected on a mirror is practically non-existent. The cast shadow, however, is projected outside the mirror.

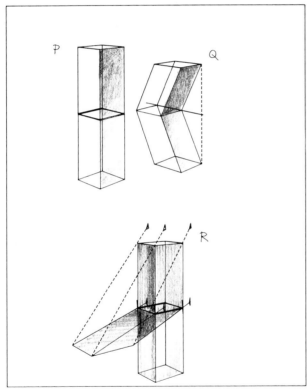

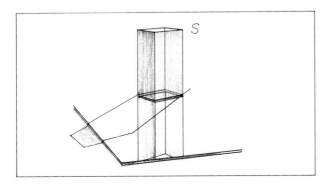

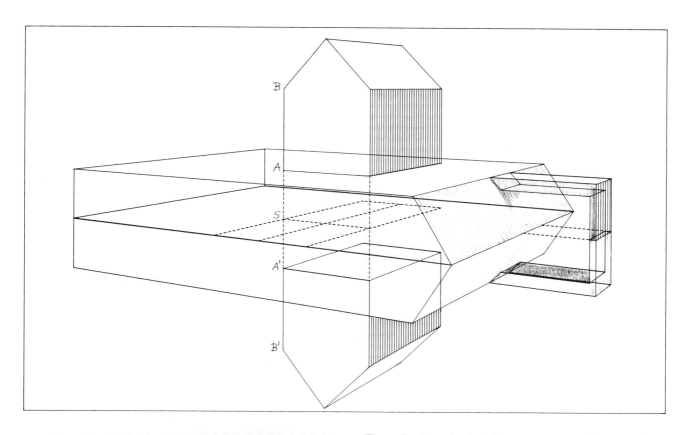

The reflection of a building on water can be compared with that of block S on the previous page. The height of the wall produces the same effect as the glass thickness. The edge AB for instance should be extended to point S in the reflecting plane. SB can then be reflected. A'B' is the reflection of AB. The embankment is of course also reflected. Therefore only part of the reflected edge AB is visible.

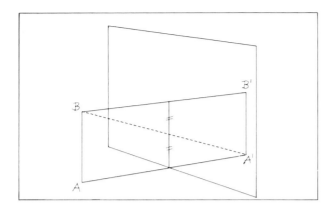

A mirror at right angles to a wall

Foreshortening should be taken into account when drawing the reflection of an object in a vertical reflecting plane. The reflection of a vertical rod AB is obtained as follows:

Draw horizontal receding lines through A and B which are at right angles to the mirror and thus run in perspective parallel.

On the basis of the construction, left, we obtain A', the reflection of point A. A'B' is the reflection of AB.

When drawing the reflection of a vertical block, the vertical edges are reflected using the method previously discussed. The horizontal edges are added afterwards. The reflected cast shadow is achieved by reflecting the vertices and by drawing the connecting lines.

The reflection of a block at an angle to the picture plane is achieved by first constructing the reflection of the bottom plane and then with the aid of vertical projecting lines such as BB". Adding the reflection of the diagonal edges completes the mirror image.

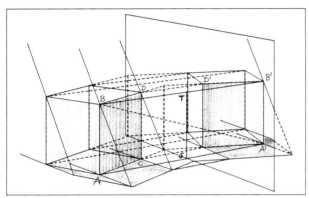

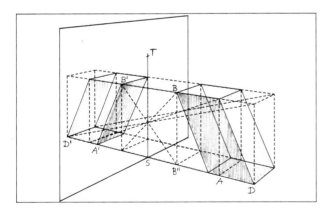

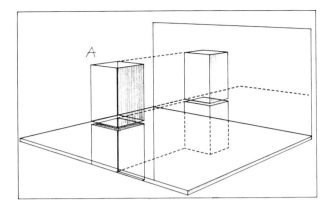

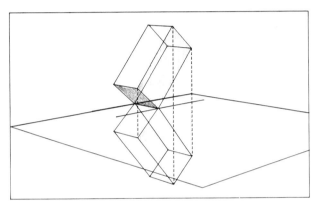

A vertical reflecting wall located on a horizontal reflecting plane produces many unexpected reflections of an object. The missing part of the mirror image of the block reflected in the vertical plane appears in addition to the direct mirror image of block A on the horizontal mirror. This part has been indicated by dotted lines.

A diagonal reflecting plane

Reflections in a diagonal reflecting plane can to some extent be compared with the reflections of a block diagonal to a reflecting ground plane. The perpendicular reflection of the block at an angle to the picture plane is illustrated opposite. If the mirror is at an angle to the picture plane, a perspective perpendicular projection on the mirror should be obtained. If a square is drawn onto the extension of the rearmost plane of the block to be reflected on the intersection line between the ground plane and the reflective plane, which is at an angle of 45°, then the diagonal AB indicates the direction of projection. The mirror image will be a horizontal block.

When a random reflective angle is chosen, the auxiliary square can be supplemented by a quarter-circle (N.B.: AB is slightly less than one third of the length of the diagonal length). If one draws the ray which lies on the inclined ramp and one draws a tangent through the point of intersection that ray and the quarter-circle, then the ray gives the appropriate angle for locating the reflected points of the plane.

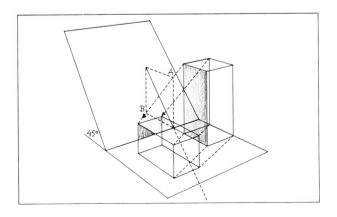

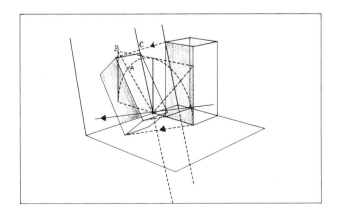

Drawing techniques for presentation

Visual representation techniques play an important role in architectural practice. Often, a great deal of information has to be communicated to third parties during the design and presentation stages. The choice of particular visual representation techniques depends on the architect's preference and of course on the knowledge and skill he possesses using various media, such as drawings, models, photographs, video recordings and computer graphics.

A thumbnail sketch in pen or pencil only has limited informative value for the layman but for the architect it is a common means of communication. Designers may be familiar with each other's style and will be able to view a sketch in its proper context. In practice sketches are presented to the layman, but there is a danger that the inability to visualize or perceive a sketch may result in misinterpretation.

It is customary for an architect to present his initial designs with the aid of 'technical' architectural drawings such as maps, plans, layouts, elevations and sections. Such drawings are drawn to scale, so that the true dimensions can be read. None of these drawings, however, offers very much spatial information about a scheme. This can make it difficult for a client to visualize the scheme's three-dimensional qualities. Isometrics, axonometrics and perspectives are welcome additions to three-dimensional representation. The first two as well as bird's eye perspectives are intended as three-dimensional outline drawings, whereas eye-level perspectives show the visual representation of objects in direct relation to their environment from a human viewpoint.

In this chapter we will examine a number of drawing techniques which can be used to present a scheme. Drawing techniques for presentation are of course subject to different trends. The *artist's impression* is a time-honoured technique but now more commercial techniques such as *photo-realistic drawings* and the *computer-aided artist's impressions* have become common. Examples of the various techniques are discussed below.

Line drawings

A drawing which only consists of lines has limited informative value. Differences in line thickness make the drawing easier to read.

Ink lines can be better reproduced in comparison to pencil lines. Improved thickness and tonal graduations, however, can be obtained with a pencil. Obviously, reproduction also depends on the photo-technical possibilities.

Architectural drawings are usually prepared on A0 or A1 paper formats. Only very detailed parts of a drawing can congeal into a single mass.

Computer drawings can be drawn on any required paper size using a plotter. The line thickness can be adapted to the format of the drawing. Detailed drawings of parts can be simplified in certain places, so that it is easier to read the drawing.

Adding tone to a line drawing

Adding tone can improve a line drawing considerably. By applying tone to windows it is possible to highlight them within the wall plane. Tone can also be used for shadows which enhances the drawing's three-dimensional quality. An example of this is the elevation drawing where the shadows cast by individual elements are added using an angle of 45°.

A third application is to highlight differences in materials. An illusion of glass can be suggested by drawing a reflective plane.

Adding colour to a line drawing

A distinction can be made between the functional and realistic use of tone and colour. The functional use of colour is found in linear relationships, planning maps and architectural drawings.

Adding colour helps to highlight different elements of the drawing. In a plan, if the buildings are colour coded, it is possible to distinguish at a glance a house from an office. The colours should be explained in a key. The realistic use of colours is intended to give a life-like rendering of the building's surfaces and the materials used in the design. Colour studies in different lighting situations can help in the preparation of realistic presentation drawings. The old rule applies here: skill depends on practice.

Pencil drawings

Lead pencils are graded according to hardness. A hard pencil is designated by the letter H and a soft pencil by the letter B. An HB pencil is of medium density. The addition of a number designates the grade of softness or hardness. A 6H pencil is very hard, much harder than say a 2H pencil which in turn is harder than an HB pencil. A 4B pencil is softer than a 2B pencil. The designations H, HB and B have unfortunately not been standardized, so that a 3B pencil of one make might compare with a 6B pencil of another make.

A hard pencil should be used for accurate drawings such as technical illustration. An H-pencil is unsuitable for drawing tonal gradations, so a softer pencil, preferably a 2B or 3B, should be used.

Three different examples of pencil techniques used for drawing a house in bird's-eye view perspective are shown on the left.

The base drawing was prepared using the techniques of perspective and cast shadow construction outlined earlier. Body and cast shadows have been built up by pencil hatching so that the direction of hatching corresponds to the direction of the plane.

Hatching a vertical plane in a vertical direction and a horizontal plane in a horizontal direction is logical and helps us to understand a drawing quickly. Hatching does not need to take very long and a hatched drawing lends itself well to photocopying.

1

In the second drawing surface texture has been added by cross-hatching. The grain of the paper then becomes visible. The ridges of the paper surface have been shaded over by the pencil, but not the grooves. The fine or coarse grain of the paper determines the degree of registration of the pencil tone. Always apply the pencil layers with a finely sharpened pencil.

Using a range of hard and soft pencils it is possible to produce accurate drawings and fine shading. At first sight the evenly rendered surface appears more realistic than the shaded drawing.

However, appearances can be deceptive! The second drawing is far from realistic because no information is revealed about the materials used. We cannot be sure, for instance, whether the walls are of stucco or brick. In order to produce a more realistic drawing we must show the different materials used. The surface quality of particular materials can be highlighted using differing pencil techniques.

2

85

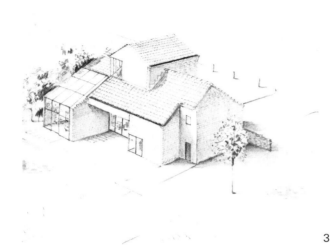

The photographs below show a tiled roof, a brick facade and a window in a brick facade. A totally different and more complete image is produced by studying these materials and introducing them into the second pencil drawing. This is illustrated by the third pencil drawing, left.

3

An example of a drawing of an office block is shown on page 89. The facade has alternate glass and aluminium panels. A tall building has been chosen in order to show the difference in reflection between the lower and upper glass panels. The lower panels reflect the adjacent buildings, trees etc. and appear darker as a result. The upper panels reflect the clear sky.

The degree of reflection in glass depends on the angle of inclination with which the degree of transparency of the material decreases. If glass is viewed from a narrow angle, then one has a perspective view in addition to reflection. To create an illusion of glass panels in a drawing we must take reflection and transparency into account.

The tone of the aluminium cladding is darker at the top and lighter at the base of the building compared to the tone of the glass in the photograph of a similar building on the facing page (see also the detailed photographs on page 88).

The surface contours of the building and the shadows on the recessed parts of the facade play an important role. Note the partly transparent corners of the building, where the glass facade 'disappears around the corner'. A detailed photograph of this phenomenon is shown on page 88 in the right-hand corner. The example on page 89 shows a pencil presentation drawing of a design for an office block made using the techniques discussed earlier.

Detailed photographs of the office building shown on page 87.

Pen and ink drawings

A choice of pens is available for pen and ink rendering such as the fineliner (a fine felt pen), the tubular-tip drawing pen (Rapidograph), the fountain pen, the dip pen and the reed pen. Each type of pen produces its own characteristic line. A dip pen can for instance be used to produce different line thickness. This is not possible with a tubular-tip drawing pen, as it has been designed especially for architectural draughtsmen for whom consistent line thickness is a prerequisite.

The fineliner is often used for sketching. Fineliner ink is quick-drying and allows the draughtsman to sketch rapidly. Moreover, there is no risk of spotting or smudging.

Pen and ink drawings lend themselves well to reproduction by a photocopier or a dyeline machine. In contrast to pencil drawings, reduction does not detract from the clarity of the drawing.

For adding tone to a pen and ink drawing a choice of materials such as a pencil, diluted ink, adhesive film, watercolour paint or a large art-marker, is available. Tone can also be applied by hatching with a pen. Three different hatching techniques can be selected:
- hatching with parallel lines which run into the direction of the plane;
- hatching with lines which form a small angle with each other;
- hatching in random direction.

Each technique is illustrated by an example on page 91/92 for which the same base drawing has been used. The first drawing is characterized by its functional character. Hatching with parallel lines into the direction of the plane rapidly produces a three-dimensional drawing which is easily reproduced.

The application of the two other hatching techniques involves more work, and there is a danger that the lines will congeal into a black mass when reduced or copied.

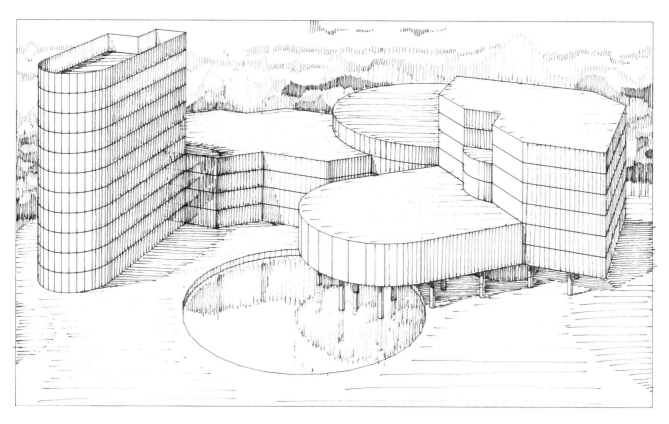

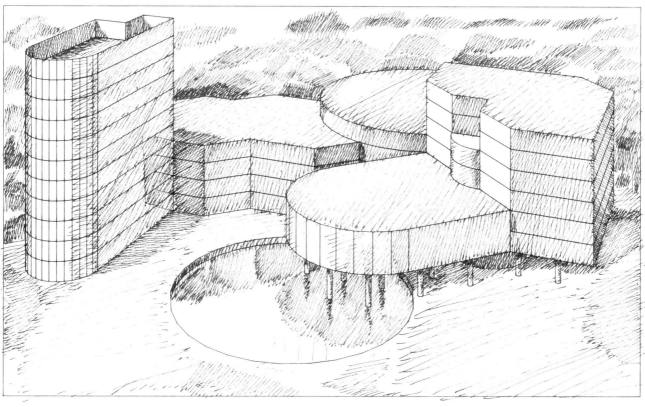

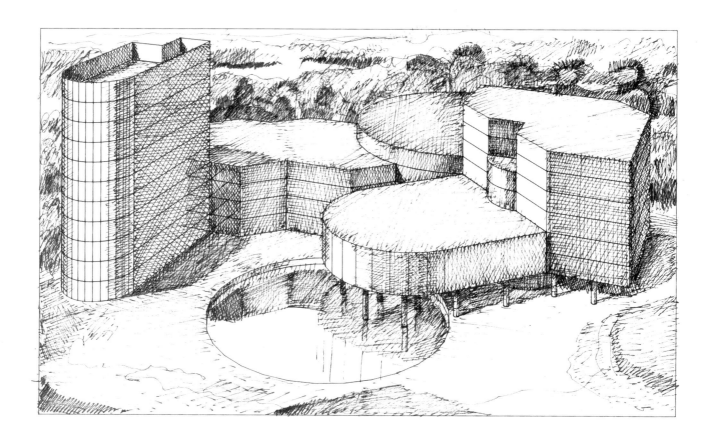

Adhesive film

Adhesive or coloured film is often used to touch up architectural perspective drawings. It enables the drawings to be read more accurately.

Working with adhesive film requires a preconceived plan. It should be decided in advance whether colour should be applied or only greys, which gradations are required, on which drawing surface or background the adhesive film should be applied or whether use should be made of the original drawing or a copy-print. Adhesive film is provided with a backing sheet. The adhesive strength of the layer of glue is such that the applied material can be removed again without damaging the drawing paper surface.

However, one should be careful. When using tracing paper it is advisable to apply the film to the reverse side of the paper. This allows ink lines to be modified or erased if necessary.

Application of the film is as follows:

Cut a section of adhesive film slightly larger than the required area with a blade so that the film covers the plane generously. Place the film in its exact position by peeling back a small part of the backing sheet and by positioning the edge of the exposed film; then rub down the rest of the adhesive film after removing the entire backing sheet. Now remove the excess material with a sharp knife – preferably a scalpel. Care should be taken not to cut through the drawing paper at the same time. Practice is required to discover how much pressure to apply on the knife. In order to ensure firm adhesion, the removed backing sheet should be placed on top of the applied film and rubbed firmly using a purpose-made tool. Possible remaining air bubbles under the adhesive film can best be pierced by a needle. If these are rubbed down into the direction of the film edges, then the film is usually damaged.

Adhesive film is sold in sheets of a 35 x 47 cm format and 50 x 66 cm format as well as 'off the roll'. The loose sheets are more expensive than the roll, but are of a better quality and come in a larger assortment of

colours. Coloured sheets in graduated shades are available in addition to sheets of even colour.

The transparent qualities of various coloured adhesive films can differ and cause variations of grey tints on the dyeline print. It is advisable to make test strips in order to determine which grey tints are produced by the various films. Some manufacturers, for instance Mecanorma, supply colour samples with grey value scales, which facilitate the choice of colours with the exact grey value. But it is still recommended to use a test strip because the dyeline print process can also influence the finished artwork

In addition to producing various shades of grey on a dyeline print, adhesive film can also be used directly for presentation drawings. The paper on which the film has to be applied must be firm and smooth, for example, tracing paper. Document paper for instance is not suitable as a drawing surface.

A range of adhesive film in approximately 200 different colours is available from Mecanorma as well as from Letraset.

Screen tints

In addition to grey and/or coloured adhesive films it is also possible to use screen tints for drawing. There are two different types of screens, adhesive screens and rub-down screens. Both types are designed to build up structures or shadow effects. A whole range of screens can be found in a Mecanorma or Letraset catalogue. The per cent marking indicates how large a percentage of the screen is black. A 20 per cent screen is darker than a 10 per cent screen. In addition to the per cent - screens there are coordinated dot screens which indicate the number of points per centimetre and coordinated line screens which indicate the number of lines per centimetre.

There are also architectonic screens with patterns such as brickwork drawn to scale and screens in even or graded tones.

The method for applying adhesive screens and adhesive film is similar. Rub-down screens are placed on transfer screens and can be removed by burnishing with a purpose-made tool. Always rub the siliconised backing sheet over the screen after application.

An example of the use of screens for presentation drawing is given overleaf; on page 107 an example of the use of coloured adhesive film is shown.

Examples of coordinated line screens (Mecanorma).

Working with adhesive screens (Mecanorma).

The use of screens in architectural drawings,
Mecanorma, O'Harris, Almere.

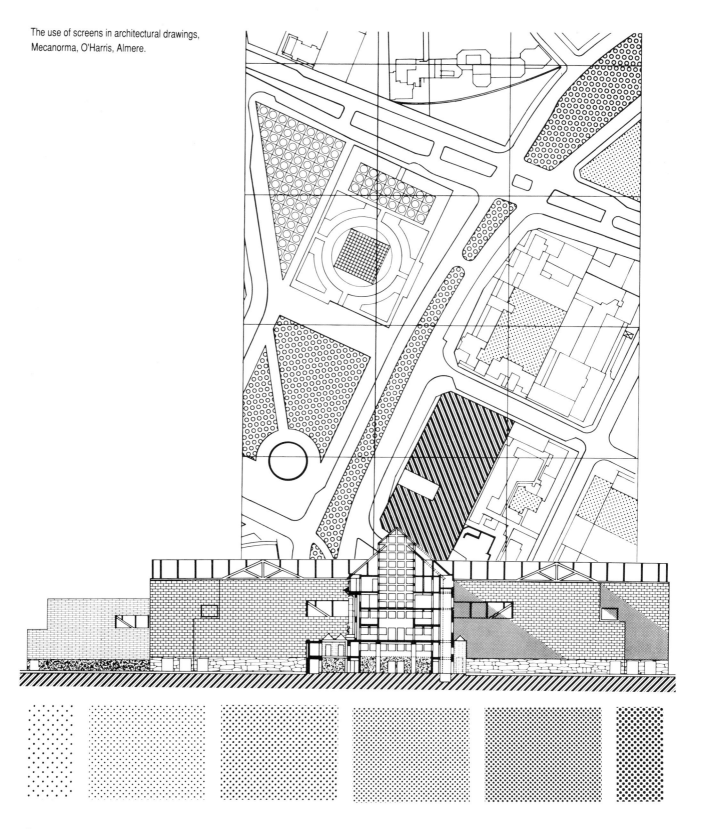

Colour

Colour is often used in presentation drawings, a distinction being made between the functional and realistic uses of colour.

In functional applications the colour serves to stress, for example, the contrast between newly-built houses and older buildings. The colour is often determined by tradition, for instance blue for cold and red for warm on water taps. The meaning of a given colour can be determined by the draughtsman, but then an explanation should be provided in a key on the drawing.

It is important to know the grey shades that different colours will produce when making a black and white reproduction of a colour drawing. A red and a green can have the same grey value, so that the contrast is lost. Always make test strips to determine the grey values of the different colours before photocopying.

Colour can also be used to obtain a more convincing rendering. Accurate colour rendering true to life depends largely on the draughtsman's observation. He should be capable of mixing colours to obtain the correct. The true colour of grass can not be obtained by choosing a random green crayon as in functional colour use. The true colour of grass is determined by a large number of factors such as the angle of view, the angle of incidence, the possible shadow, the type of grass, whether it is young or old, mowed or not, wet or dry. Even the choice of the rub-down colour material can influence the colour rendering. Using a crayon (coloured pencil) reveals the grain of the paper. The area of the paper surface which has not been touched by the pencil retains the paper colour, so that the green colour mixes optically with white for instance. A matt-drying paint such as watercolour paint has a different colour when wet than when dry. The light penetrates through the wet paint onto the background – and reflects through the paint – this phenomenon is called deep reflection – whereas in the case of dry paint only the surface reflects the light.

We will limit ourselves in this chapter to a simple colour wheel and some examples of mixing techniques which should make the reproduction of true colours easier.

Mixing colour

In colour mixing we distinguish between *additive* and *subtractive mixing*. The first method, as the word suggests, is based on the adding or in this case the combining of different coloured light until a white light emerges.

If rays of white light pass through a prism the white light rays are refracted and separated into the different colours of the spectrum. This phenomenon is well-known. Recombination of the monochromatic components gives white light.

The second method of colour mixing is based on the subtraction or removal of light. The artist is more familiar with this method. He knows that he obtains green by mixing blue and yellow paint. If he mixes all colours together he will obtain not white but black or dark brown.

A simple colour wheel is based on three base colours: red, yellow and blue, also called *primary colours*. The colour wheel presented on this page has the base colours arranged equidistantly around the circumference. If two primary colours are mixed one obtains a secondary colour. Purple, orange and green are such secondary colours and are opposite the primary colours. The secondary colour green is directly opposite the primary colour red and the complement of both colours is black or dark grey. They are called *complementary colours* or *minus colours*. Two colours close to each other on the colour wheel will harmonize with each other; when they are mixed together they will neutralize each other.

Skill is required to place the correct colour green opposite the correct colour red. If there is too much brown after mixing then the green will contain too many yellow elements and a small quantity of blue or bluish-green should be added to obtain a black or dark grey colour. An example of mixing is presented overleaf.
The true complementary colours, red, yellow and blue, respectively, are obtained using coloured pencils such as Derwent pencils, for mixing .

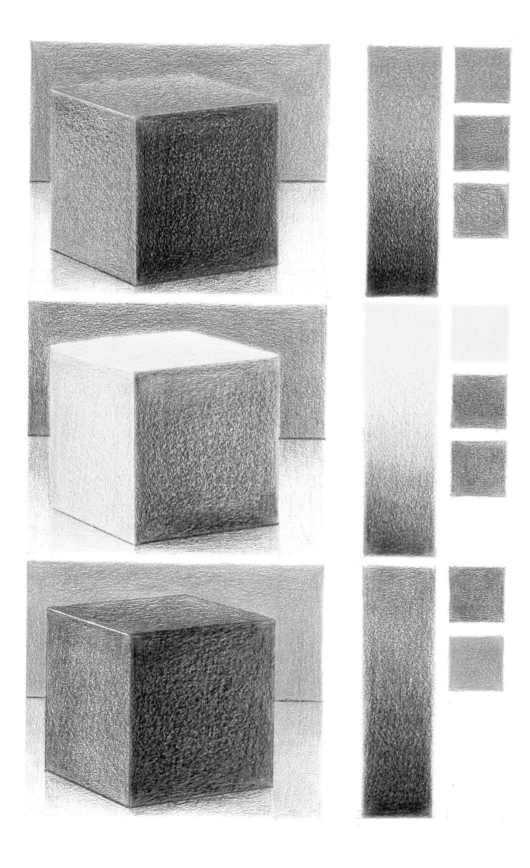

Coloured pencils

A coloured pencil drawing has a character of its own. The grain of the paper will become more or less visible depending on the type of paper. The colour also plays a role. Preparing a colour drawing is time-consuming. A mixed colour is obtained by applying successive layers of given colours. When too much pressure is applied on the pencil, the layer becomes too smooth which makes putting another colout on top difficult. It is important to develop a good mixing technique. Even if one does not intend to make any colour pencil drawings, this technique can still be useful for the combined art-marker/crayon drawings. This technique is elaborated on page 102. An example of a coloured pencil drawing is shown on this page.

The quality of coloured pencils is determined by the degree of colour registration. A soft coloured pencil is more suitable for this purpose than a hard pencil. A coloured pencil should have a consistent composition. Cheap pencils often contain hard particles which make irreparable scratches on the paper. The coloured pencils used for this book are Derwent pencils (Derwent artists fine art coloured pencils, Rexel Cumberland, 72 pencils) in conjunction with a few Caran d'Ache Prismalo coloured pencils. There are also 'watercolour' pencils on the market. Quite disappointing results are obtained with these pencils when they are used for commercial purposes. The colour changes drastically when a dry layer is moistened. If one wants to paint in watercolour, then one should use watercolour paint.

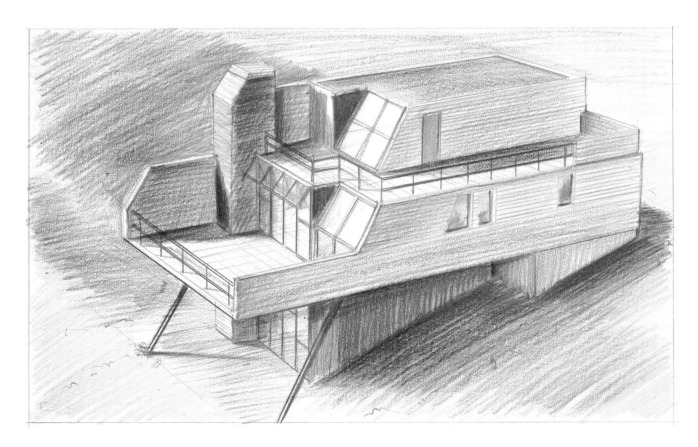

Watercolour paint

Watercolour paint used to be considered the ideal material to colour architectural presentation drawings. Because transparent watercolour paint is used rather than finishing paint it is possible to colour in a drawing without loss of lines.

Watercolour paint can best be used on special watercolour paint paper; a range of different paper with a coarse or fine texture is available. Care should be taken that the paper is sized well when it is purchased – this prevents the paint bleeding through the paper – and make sure that it is colourfast. If the paper were to fade then the colour would also fade.

Watercolour paint, diluted with water, is applied in transparent washes using a brush. The water causes the paper to expand, especially when thinner types of paper are used. It is therefore recommended to wet the watercolour paper in advance and to fix the paper to a piece of board using gummed paper. When the paper dries, it shrinks and automatically stretches itself. Sellotape is not suitable for mounting purposes, because it does not stick to a wet surface.

Optical mixing results when transparent watercolour paint layers are superimposed on each other. When a yellow layer is laid over a blue layer, the result is green. In addition to this layering technique is it also possible to paint in watercolours using a wet method, which means that the colours are mixed directly on the paper. This method is for instance useful for shaded colours and textures. Usually both techniques are used in watercolour rendering.

Watercolour techniques are very difficult and require great skill, because it is a very direct medium. In order to compare the different techniques the same base drawing is shown rendered in coloured pencil and in watercolours.

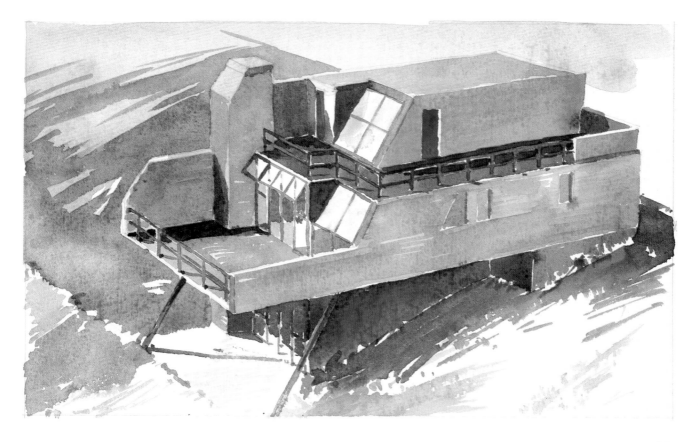

Winsor & Newton watercolour paint is of excellent quality. A useful basic set of watercolour paints may contain the following colours:
Cadmium red
Cadmium yellow
Burnt sienna
Yellow ochre
Ultramarine
Russian blue
Cobalt blue.

A watercolour brush should be soft and pliable. It should also be absorbent and have a point. The best watercolour brushes are made of sable hair. Unfortunately it is very expensive. A reasonable alternative is a French ornamental brush. Do not choose a brush which is too thin – a medium-sized brush is suitable for most tasks.

Large felt-pens or art-markers

A felt-pen consists of a tubular holder with an ink reservoir and a fibre tip. The felt tip varies in thickness and shape. The felt-pens which produce thin lines are known as fineliners; the larger ones are called markers. The latter are designed to colour in large surfaces. The usually waterproof marker ink can fade quickly under direct sunlight. In practice, felt-pen drawings are usually photographed immediately after they have been completed, for slide presentations for example.
Markers are used to an increasing extent in architectural offices. The quick-drying ink improves the process and markers can also be combined with other drawing aids.
A large range of coloured markers are available from Pantone, Mecanorma and Magic Marker – the range consists of some 200 different kinds of markers – which unfortunately do not always mix well together.
Marker ink is transparent. A mixing colour is obtained by applying additional layers as for watercolours. The ink can also contain a noxious thinner and it is recommended that the workspace is well ventilated.

A basic set of markers can consist of a series of grey shades, a black marker and various colours. If one decides on a large Pantone marker, then the set can contain the following:
- cool grey 2M, 6 M and 11 M;
- black M;
- warm red M, yellow 116 M, light ochre 466 M, light green 351 M, process blue M and a light blue 277 M.

Marker paper

There is paper on the market which has been especially designed for drawing with markers. Only one side of the marker paper can be used as a result of the special glue. Felt-pen ink applied to the reverse side of the paper is only partly absorbed. This results in a sticky layer. It is therefore a good idea to check whether you are using the correct side of the paper. Setting-up a drawing usually requires time and it can be a frustrating experience to discover that the finished drawing has been drawn on the wrong side of the paper. There is no other alternative but to start again.

Canson paper

Canson paper can also be used for drawing with markers. This paper has a velvety surface and is available in several tints.

Blocking in surfaces with markers

Blocking in a surface by drawing lines in one direction with a large marker results in a smeary mess. The marker ink dries so fast that the overlap of the lines becomes visible. An even colour can be obtained by shading the plane rapidly from one angle and by rapidly burnishing with a finger or tissue over the partially dry surface. This burnishing technique can also help if tonal gradations are required. Always start with the lightest shade, then progress to the darker shades until the required tonal gradations are obtained. The sticky shiny spots which appear when several layers are superimposed can be taken off with a tissue.

Applying marker ink to the reverse side of the marker paper can cause special effects. When tones are set up on this side – actually the wrong side – this tone will appear as a lighter tone on the right side because of the transparent nature of the paper. If a large quantity of marker ink is applied to the reverse side of the paper, the front face of the paper will be saturated with ink and produce a mottled surface.

Because marker ink dries fast, markers are very useful for the preparation of thumbnail sketches which an excellent way of presenting concepts and the organisation of ideas at the design stage. Such thumbnail sketches are set up with a fineliner in conjunction with a large marker.

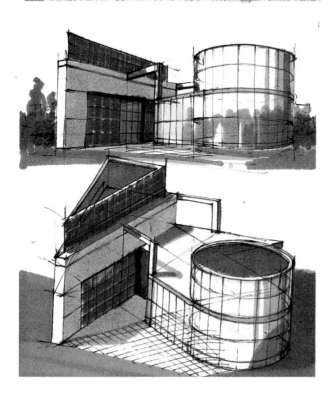

Setting-up and touching-up presentation drawings

On this page and the three following pages we show how a presentation drawing is prepared on a step by step basis, using markers, fineliners, pastels, coloured pencils and poster paint. Each step is explained in detail, starting with setting up the drawing.

The setting-up is initially done using a grey fineliner and a ruler. After the direction of sunlight has been chosen, all the so-called shadow projection lines are traced with a heavy fineliner and the body and cast shadows are blocked in with grey markers.

In fact, the drawing on this page is a computer drawing in ink, which has been plotted on marker paper. Pantone markers (cool grey 8 M and 11M, black F and 417 E) were used for the varying tints of grey.

Coloured markers are used after the work with the grey markers is finished. When using large markers, care should be taken to avoid detracting from the accuracy of the rendering. Always think about what you are drawing, especially where the treatment of glass panels is concerned. Remember that a colour in the environment changes to grey as a result of reflective glass. An AD-marker (apple green P28) was used for the natural setting in conjunction with Pantone 279M (blue) and 351M.

However accurate the drawing, the results of these preliminary stages will not be satisfactory in themselves. This is quite normal when using this technique and one should not be too easily discouraged.

Pastels and coloured pencils are used for the next phase. Pastels are used to smooth out planes or to apply tonal gradations. They can also be used to obtain colour harmony. Never apply pastels directly onto the drawing. Pastels can contain hard pieces which cause irreparable scratches on the paper surface.

Prepare scrapings from the crayons with a knife and burnish these onto the paper with a tissue. The excess particles can be removed with a soft eraser. An eraser pencil can help with the fine artwork. A Faber-Castell eraser pencil contains two different grades of eraser.

Coloured pencil is the ideal method for developing the drawing further. Always use coloured pencils after pastels and not vice versa. Pastels will not stick to the slightly greasy coloured pencil. Derwent coloured pencils in conjunction with some coloured pencils from Caran d'Ache were used for this drawing.

Finally the black lines can be touched up using a black fineliner and highlights applied. White poster paint lines should be applied with a ruling pen where necessary.
Proceed as follows:
Paint and water are mixed in a small dish with a brush, so that the paint flows freely when ruling the lines and covers properly. A quantity of diluted paint is applied between the two legs of the ruling pen with the brush. If too much paint is soaked up, the paint will spontaneously flow out of the ruling pen. Try the ruling pen first on a piece of scrap paper and experiment to find the best line thickness. The required lines can then be drawn with the ruling pen which is held perpendicular to the paper. Holding the pen at an angle results in staggered lines and ruins the instrument in the long run. Use a ruler with a raised edge to prevent the paint from flowing under it.

Additional presentation drawing techniques

Rubbing

If a sheet of paper is placed over a background with surface-relief and we shade across it with a pencil or coloured pencil, the underlying structure will be revealed on the paper. Such a print is called a rubbing. A range of textures can be achieved depending on the chosen, a coin, for example.

Thinner print

Shown opposite is an example of a print in mirror image made from a photograph out of a magazine. To make such a print, first place the chosen photograph image upwards on a sheet of paper. Moisten the reverse side of the photograph with thinner and burnish with a spatula or spoon until the photograph has been printed onto the paper.

Photocopying

A photocopier can be used to transfer photographic material to a drawing. This is useful for those who are not that skilful in rendering the human figure, for example. The possibility of enlargement and reduction by means of photocopying can also be used to advantage. A photocopied figure pasted onto a drawing can improve its realism.

N.B. The toner used in photocopiers dissolves in thinners and also in the spirit in felt-pens.

On this page and overleaf, a few different presentation drawings are shown: a drawing on Canson paper, a drawing overlaid with adhesive film and a dyeline print of a presentation drawing in the preliminary and final stages of colouring.

Architect Jan Brouwer; design for competition, dyeline print on contrast paper with adhesive coloured films.

Ir. Kees van der Hoeve in collaboration with Ir. Karel Rosdorff. New housing development of the Department of Posts and Telegraphs, The Hague, drawing on Canson paper using marker technique: Peter de Wolf, Delft.

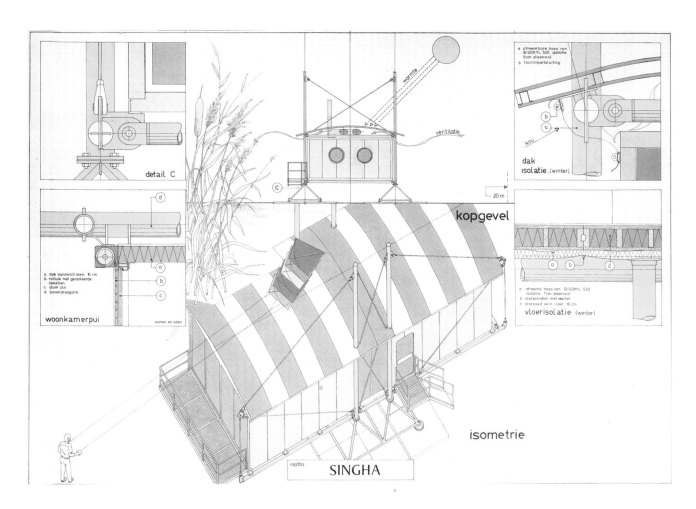

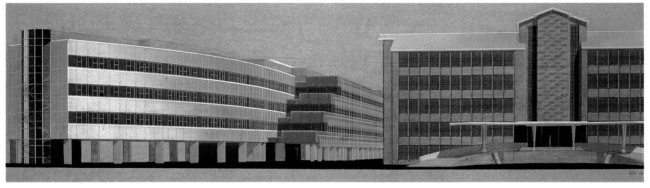

Design of stadium by the Committee of the Olympic Games, Amsterdam 1992.
Preliminary drawing (above) and final drawing (below) – using marker
technique.

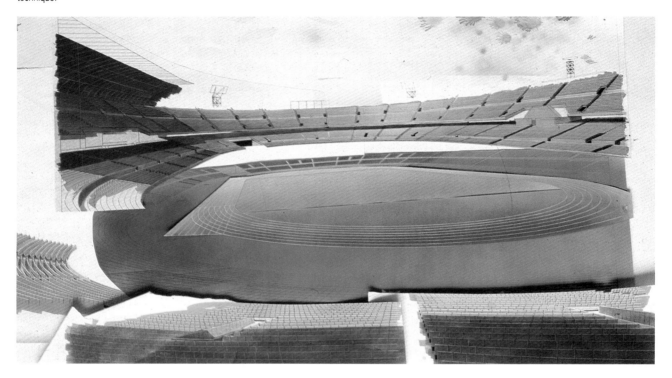

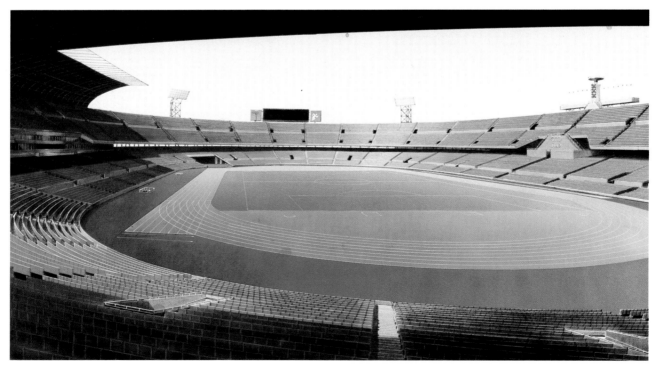

Computer graphics

With the advent of the computer a whole new dimension has been added to drawing. The term computer graphics refers to the graphical representation possibilities of the computer, both on a two-dimensional flat surface and in three-dimensional space.

The use of a computer opens up unprecedented possibilities for the artist. Data which has been input can be retrieved at any time, a printed record of the data can be produced on a printer or plotter, data can be modified, enlarged or reduced and can be sent by modem, a device which allows computers to communicate along telephone lines. The traditional freehand drawing, which has to be kept in a voluminous plan chest, now has its little brother which can be stored on a small part of a disk.

The input of data which are necessary for the preparation of a complete drawing is even more time-consuming than a freehand drawing. However, if the drawing has to be modified or the design has to be viewed from a different angle then computer-graphics patterns can be erased and changed almost instantly using simple computer commands, whereas a freehand drawing will have to be drawn again.

The term CAD is an acronym for Computer-Aided Design and/or Computer-Aided Draughting. These programmes produce a visual output of sketches and/or drawings. The term CAD/CAM is also used in the field of computers. CAM is an acronym for Computer-Aided Manufacturing. The term is applied to the use of a computer as a tool for the manufacture or assembly of products. A computer-assisted milling machine translates the input data into machine movements. In this chapter we discuss Computer-Aided Draughting as an introduction to computer graphics.

A CAD-system in principle consists of a computer, an external memory, a monitor, a keyboard laid out in the conventional typewriter style with additional function keys, a mouse (or cursor or hand-held reader) and a plotter and/or printer. The CAD system does not work without a programme loaded into the computer. A standard programme is stored in a so-called ROM (Read-only-Memory). The computer also has a RAM (Random Access Memory). The total memory is called the internal memory. The external memory consists of information which is stored on a floppy disk or hard disk. A floppy disk can contain a maximum of one million bytes (approximately one megabyte); a hard disk can contain up to 100 megabytes. A hard disk offers the advantage of faster speed.

CAD-system used on Atari 1040 ST
with A3 plotter

It is important to the artist/designer that the chosen computer system is user-friendly. A user-friendly system should be fast, efficient and easily understood. The artist/designer does not usually want to devise new programmes written in complicated machine code and opts for software programmes designed by software engineers which are geared to his needs. A user-friendly computer works according to the principle of question and answer. A menu appears on the computer screen listing a set of options that the user can select in a given programme. The user then selects his option by moving a cursor control key or a 'mouse'. The computer executes the command which in turn may trigger a follow-up question. Function keys on the keyboard are used to start and finish a command. There are computer systems where menus do not appear on the screen but which use a graphics tablet on which several menus can be placed and then read with a hand-held pen. The entire screen can then be used for the preparation of a drawing.

The quality of computer screens is often disappointing. Computer monitors with a low resolution have a small number of controlled points and this results in annoying staggered lines. Colour-monitors often have a low resolution which means that the monochrome monitors are more suitable for graphics.

The plotter changes the visible staggered lines on the screen into flowing lines and thus produces a good quality drawing.

Three-dimensional computer drawings

The computer will come to play an important part in the representation of three-dimensional images. With 3D (three-dimensional) programs drawings in isometric and axonometric projection can be prepared as well as drawings in perspective. When the necessary data – plans and elevations have been input, the computer can draw a three-dimensional image. This is especially useful when developing a design because it provides an opportunity to assess the three-dimensional implications of a concept.

The preparation of three-dimensional drawings under computer control is done as follows:

a. Layers are used to input the necessary data for the plan such as plans and elevations. The layers can be compared with transparent sheets on which the separate parts at the same scale have been separately drawn. All layers can be called to the screen either simultaneously or individually. The data contained in each layer is recorded on a list, for instance layer 1–plan, layer 2–plan, layer 3–north elevation etc.

b. Indicate the chosen viewpoint on the plan drawing.
c. Input the chosen eye-level/horizon level.
d. Input the chosen line of vision.
e. Indicate the chosen angle of view in degrees.

The required perspective will be drawn as a 'wire model' on the screen under computer control. The computer defines all line perspectives of the prepared layers including those not visible from the chosen viewpoint. A hidden line removal program can clear a computer file leaving only the visible lines.

Some programs will calculate the shade value of the body shadow planes, the cast shadows and the reflections after the chosen light direction has been input.

The drawing of wire models is also known as *wire-frame modelling*. In addition there are two other computer techniques – *surface modelling* and *solid modelling* – which are outside the scope of this book.

On page 112 a computer presentation technique is illustrated. This example is referred to as a computer-aided artist's impression. It shows the design of an Olympic stadium drawn over an aerial photograph presented to support the nomination of Amsterdam for the 1992 Olympic Games. Drawing and photograph had to be combined to produce a realistic representation.

First the plan and the stadium design had to be input into the computer. The photographer's viewpoint and the angle of view were reconstructed on the basis of an analysis of the aerial photograph. The principal lines on the photograph were digitized by means of a graphics tablet and subsequently input into the computer. A perspective was then drawn under computer control which was verified on the basis of the digitized photograph. The corrected version was then plotted to true scale on a transparency and was printed to paper. The reproduction has been worked with the aid of markers, pastels and coloured pencil. The drawing is then introduced into the photograph, finished and colours blended in using a coloured pencil. Parts of the photograph have been retouched with an airbrush. The presentation techniques used are described on pages 102–105.

Monitor photograph, perspective of urban development study for the Weena region, Town Council of Urban Development, Rotterdam.

Monitor photograph, urban development design and elevations for volume study for the Weena region, Town Council of Urban Development, Rotterdam.

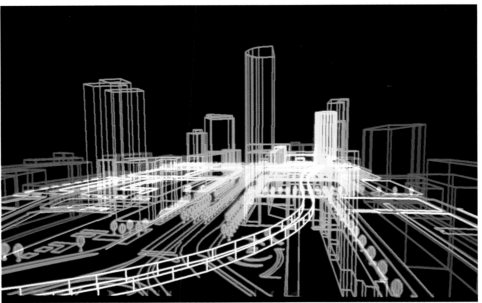

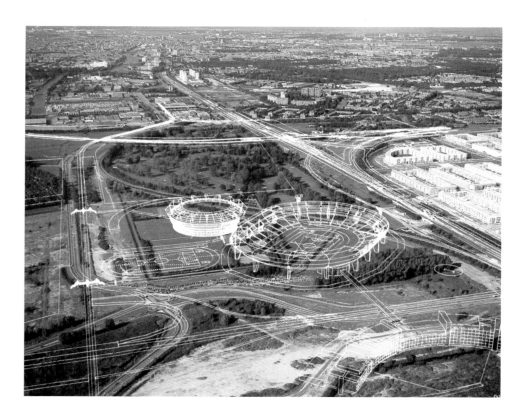

Computer drawing of stadium – Committee for the Olympic Games Amsterdam 1992, Grabowsky & Poort, The Hague, drawn over an aerial photograph. Aerial photograph: Aerophoto Schiphol B.V.

Hand-drawn developed computer drawing using marker technique, Erik van Kuijk, Delft.

Scale models

In addition to the two-dimensional drawings, photographs and the computer drawings – three-dimensional models are used to visualize architectural designs and urban developments.

For practical reasons, these are made to a scale that allows the model to be easily handled. A scale of 1:1000 or 1:500 is common for urban development designs, whereas a scale of 1:100, 1:50 or 1:20 is chosen for buildings. However, scale can sometimes be confusing. Models are usually looked at from a bird's-eye view and even when a normal eye-level viewpoint is assumed, then a good deal of imagination is needed to get a realistic impression of the design.

In addition to scale models one can also make life-size models. These are mainly used for studying anthropometry and ergonomics for instance. The height of a kitchen sink and the layout of an experimental house can only be tested in practice.

These life-size models are not only produced for study purposes; complete buildings are sometimes constructed in large urban developments for viewing by housing associations for example. A building system has been especially developed for that purpose using hollow wooden building-blocks, beams, window frames and floor boards. It is possible to give a better graphic explanation of a typical house using a full size mock up. Future residents – usually laymen – can better visualize the design when they are presented with a one-to-one model than with a drawing or scale model.

Two different kinds of model are used in architecture: *sketch models* and *presentation models.*

Life-size models or mock-ups are designed for use in the development stage as a way of interpreting the three-dimensional qualities of an interior, a building or urban environment and to show the achievements and limitations of the chosen design. These sketch models should allow for rapid construction and modification. Often they are made from materials such as cardboard or polystyrene.

Cardboard sketch model, Arch. Ir. Jan Verbeek Amsterdam.

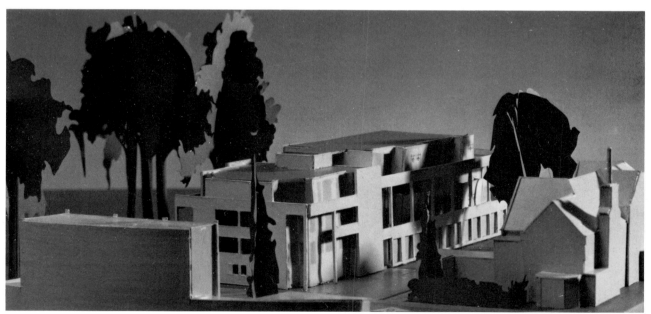

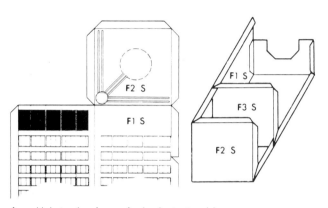

Assembly instructions for a professional cut-out model.

Cardboard sketch models

A thin cardboard model can be constructed in the same way as a cut-out model.

Draw the tongues, which are needed to stick the different parts together, in the appropriate places. Write on the tongue which item will be glued on it, so that the loose components can be identified. Use a sharp knife (a Stanley knife or scalpel), a steel ruler and a cutting board. If required, windows should be cut out before the facade has been cut out. In order to be able to fold the tongues sharply, it is best to score the folding line slightly – on the correct side of the cardboard!

The entire construction is fixed using quick-drying transparent glue. A thicker piece of cardboard can be used as a base on which the plan or design has been drawn. Styrofoam and chipboard are often used for this purpose. If the drawing surface is solid enough, then a dyeline print of the design can be glued onto it without bending the base plate.

The roof planes can be painted or covered with fine abrasive paper. The base plate can be finished by painting the boards grey. Only the most basic elements are necessary for a working model. Adding stylised trees, for example, only helps as a clue to and not to increase the realism of the design.

Fastener tongues should not be used when making models from thicker cardboard. A better result will be obtained by using glue to bind the parts together. Two perpendicular intersecting planes can be assembled by halving both pieces to produce a sliding joint. Bonding then becomes superfluous.

The cardboard can warp as a result of bonding and painting. To prevent this the cardboard should be treated with the same material on both sides. This is time-consuming work which can be avoided by using double-sided covered cardboard or greyboard.

Cutting apparatus for polystyrene.

Polystyrene sketch models

Urban development sketch models are often made of polystyrene. This is a synthetic foam, available in sheets of different thickness. The familiar white polystyrene – also called polystyrene foam – has a coarse and open cell texture and can be cut with a sharp knife or a saw with fine straight teeth. A hot wire cutter can be used for cutting materials which melt easily. The entire construction is fixed on a base plate, in which a hole has been cut, through which the cutting wire is fed.

To assemble the parts on the base plate, either pins or glue can be used. Not every glue is suitable, because many kinds of glue dissolve the polystyrene. The best results are obtained with rubber solution.

White polystyrene is more suitable for use with blocks than for finer details. Elevational details can be drawn on a piece of paper and then fixed to the polystyrene with pins.

A better quality polystyrene foam with a finer and closed cell texture is Roofmate. In contrast to the white polystyrene an accurate finish on this material can be obtained with abrasive paper. The colour of the material – light blue or light green – is sometimes seen as a disadvantage.

In addition to the different types of polystyrene there is polyurethane foam which is granular and usually has a brown colour. This easily worked material also lends itself to abrading.

Polystyrene and coloured paper sketch model, design study, student project, University of Delft, Civil Engineering Faculty.

Sketch models in other materials

In addition to the previously mentioned structural materials, cardboard and polystyrene foam, various other materials are used such as transparent polyacetate can be used for the simulation of illuminated streets and cocktail sticks for the simulation of columns.

Plasticine can also be used. The advantage of plasticine is that it does not dry out but stays soft and does not shrink. There are no rules for the use of different materials, some people use cocktail sticks to suggest columns, others prefer welding wire. A person who is more skilful in working with wood will prefer this material to polystyrene.

Combining different materials often causes problems because of the colour differences in material, others do not consider this a drawback, especially when the material is used for sketch models. Sketch models as well as design sketches are designed for use inside the office may not be as informative as outsiders.

Presentation models

The construction of presentation models and the preparation of presentation drawings requires some skill. Presentation models cannot be made quickly. It is a time-consuming activity and a lot of machinery is necessary to carry out the precision work involved. Some techniques for constructing presentation models are discussed below.

Presentation models in wood

Urban development presentation models are often made out of wood. The harder types of wood are generally used. Hardwood is very suitable if good woodworking tools are available. It is advisable not to use softwood, it splinters easily and is full of knots. The finishing – sanding and filling – takes up a lot of time. To construct a complicated form it is often easier to use glued woodstrips to build up the model than solid blocks of wood. Wood glue can be used for bonding. The entire construction is likely to be heavy and it is better to assemble separate wooden components for a large wood model that is to be moved about.

Some cities keep wooden models of large parts of the city centre which can be adapted to keep both users and developers informed of future plans and urban developments. The removable components are made such that additions and modifications are possible without having to construct a new model each time a change is made. The model section of the Spuikwartier in The Hague – a fast-changing area - has been built up with blocks which indicate the maximum height measurements and volume for the zoning plan.

To finalise the plans for the various sections, the simple massing blocks can be replaced by more detailed blocks. As a result of this it is possible to get an up-to-date overall picture of the planning developments in the town centre.

Model in wood, spray-painted white. Plan Development Spuikwartier, The Hague 1987, Municipal Council for City Planning and Property Development.

Model in wood, concept plan. Plan Development Spuikwartier, The Hague, Municipal Council for City Planning and Property Development.

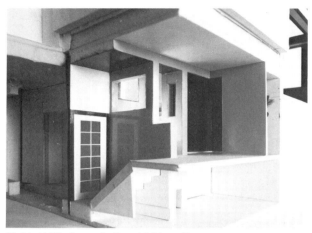

Apart from solid wood, other building materials are suitable for constructing models. Depending on the scale required, hardboard, multiplex, chipboard or blockboard can be used. To limit the weight of the model, balsa wood, which is very light, is used for the representation of building designs. Balsa wood is available in different grades of thickness up to sheets of a few millimetres thick. It can be sawn and sanded quite easily, is easily worked with a sharp knife and lends itself perfectly to the construction of very detailed models.

Model of Müller house: Architect Adolf Loos, Prague 1928/30 constructed by D. v.d. Dolder and M. Voet, perspex, impact-resistant polystyrene and hardboard.

Model of Moller house: Architect Adolf Loos, Vienna 1927/28, scale 1:20, constructed by Dick van Gameren, Esther Gramsbergen, Max Risselada.

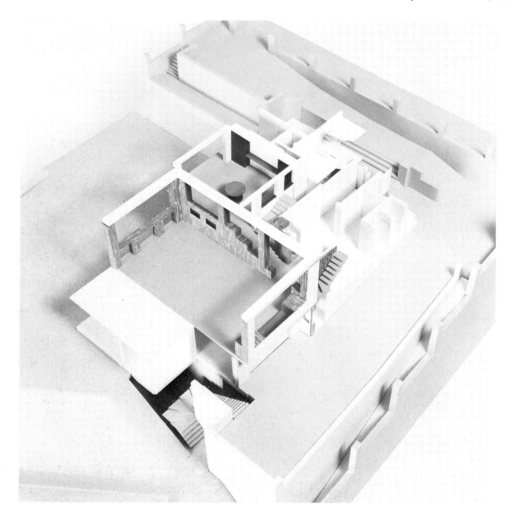

Presentation models in synthetic materials

In addition to polystyrene foam, Perspex is an excellent material for presentation models. It is available in different thicknesses and colours and in gradations ranging from clear transparent to opaque. The thicker Perspex sheets can be sawn with a jigsaw or circular saw with a special blade. A protective sheet is attached to both sides of the the material. To prevent damage to the surface, the protective sheets are only removed after sawing and shaping by abrasion. Sawing produces a rough, opaque, saw-cut. The saw-cut can become smooth and transparent again by sanding with fine abrasive paper and by polishing it with, for instance, Brasso metal polish.

It is advisable to score thinner Perspex sheets with a knife and then break the material. The result is a flawless fracture line, which does not have to be sanded down. Breaking the Perspex does involve some risk. Various good types of glue are on the market to glue the Perspex parts together. A clear joint is obtained by applying chloroform to the planes with a hypodermic syringe. Chloroform dissolves the surface of the Perspex, causing the material to melt.

A special characteristic of Perspex is that cut lines are clearly visible on a smooth surface. A facade design can be introduced into the model quite simply as a result. This technique is often used for models of office blocks with glass facades.

Computer-assisted cutting tools can be used to construct entire facade planes. The cutting depth can be adjusted.

It is also possible to cover Perspex with adhesive film because of its smooth surface. This can also be cut by computer-assisted cutting tools. When clear transparent Perspex is covered with non-transparent adhesive film and the window planes are removed, a realistic rendering of a glass panel facade can be achieved.

Apart from Perspex there are other easily worked synthetic materials which can be used in a similar way. Plate glass, a currently much-used building material, can be simulated convincingly using reflecting synthetic board.

Presentation model for the Oosterdok project, Amsterdam. Architect K. van Velsen. Model: Kappers Vormgeving, Rotterdam.

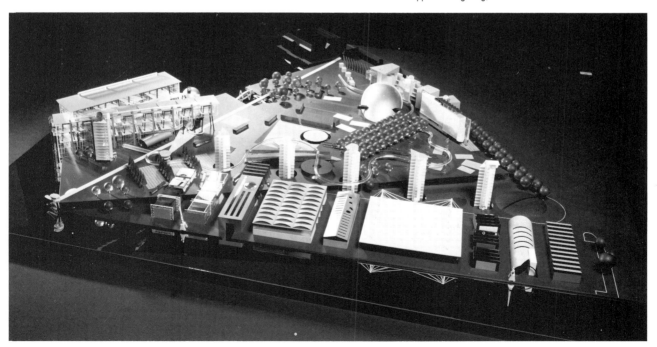

Presentation models in other materials

Wood is used less and less for constructing models because the suitable types of wood are expensive and painting is difficult and time-consuming. Perspex on the contrary has a smooth surface, and does not have to be sanded or filled and can be spray-painted in any required colour. It also combines well with other materials.

Depending on the structural possibilities, the model-maker has a choice of an unlimited range of materials such as lead, perforated sheets, copper and gauze. In one model, polystyrene or cork balls on sticks can be used to simulate trees and in other models pieces of sea cucumber, painted sponge or plasticized or artificial branches might be used.

Scale models of human figures, cars and trains obtainable from model-making shops can be used as 'props'. The disadvantage in using scale models of cars is that that the usually old-fashioned model cars look out of place next to the new buildings.

Enthescope display in the Faculty of Civil Engineering of the University Delft.

The enthescope

On page 109 we mentioned that some imagination was needed to interpret a design in model form. Even when viewing the model from a normal eye-level point, it is not always easy. Too much cluttered information is present. The small-scale model can be difficult to understand.

To obtain a better impression of reality the enthescope has been developed. This apparatus is a controllable combination of a camera or video camera and an endoscope, an instrument used in the field of medicine to look inside the human body.

Using the enthescope photographs can be made from a scaled-down eye-level. Using a remote control device, the 'eye' can travel through the model and make a video recording. The moving images allow the observer to experience the design and judge its three-dimensional quality and are thus highly informative.

Shockproof video recordings should be made and the image should be congruent to the movement of the retina. But close-ups if they are to be convincing require a high level of detail in the model. Coarse model surfaces and small construction errors will be irrevocably exposed and invariably detract from the overall impression. Polystyrene which has an open cell texture is obviously inappropriate. The enthescope, which has become an indispensable apparatus for the architect during the design and presentation phase, will no doubt be ousted by the computer in the near future, as computer animations can generate far more realistic images.

Monitor display of enthescope.

Monitor display of study design. Buildings constructed over the Utrechtse Baan, The Hague, Municipal Council for City Planning and Property Development.

121

Photography

Some hints for photography on location

Every architect occasionally uses photographs. At a simple level, photographs record the existing architectural environment and provide information about a design. They provide factual detail or capture fleeting moments of action in particular weather or traffic conditions. They enable the architect to test his final design against the original basic concept and can produce a wealth of reference information for the preparation of a new design.

Photographic techniques are part and parcel of the architect's basic skills. He should be able to take a simple, objective photograph – 'this is a building...built in the year...' as well as a more involved, subjective photograph – 'the building is less impressive when seen from this angle, because...' or 'the building is in harmony with the environment because...'

Some architects make a documentary record of an existing site or environment as part of the initial design process. This documentation can consist of drawings of plans, elevations, details, perspectives – supplemented by photographs or video recorded images.

The problem is that photographs and videos record images that capture all the available information but do not stress any particular features. Distracting or irrrelevant material can not be left out, except with equipment designed for image correction. We have to refer back to a drawing which allows for the inclusion or omission of objects. A tree or a car can be drawn as if it is transparent or can simply be omitted.

A photograph should provide an image that is congruent to the associated image on the human retina. This is not possible in every situation. The angle of view can be too narrow for instance to accommodate the whole object. In that case it is best to use a wide angle

Photomontage by Maarten Sanders.

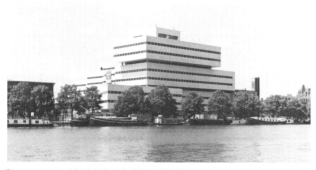

Photomontage of final design. Architect: Maaskant,
Van Dommelen, Kroos and Senf.

Photomontage of a model combined with a photograph of a new housing
development for the Department of VROM, The Hague.
Architect: HWT, Rotterdam, Prof. J. Hoogstad.

lens, that is, a lens which has a wider angle of view than the human retina. The danger is that distortion may occur. A building can appear wider than in reality, or a street may appear much wider and the architect should bear this in mind. Another hindrance can be converging verticals, which result from the use of a wide angle lens. When the vertical lines converge strongly facades can appear to lean backwards. This distortion is produced when the camera is not held horizontally. To avoid this effect, an architectural lens or 'tilt and shift lens', a lens which corrects the converging verticals, can be used. Converging verticals can also be corrected by tilting the masking frame in the direction opposed to the convergence in the negative. Correcting converging verticals, however, always remains a difficult procedure. Paradoxically a photograph can appear more realistic if there is some apparent distortion of reality.

Photography always produces a static perspective. We experience a changing perspective when walking through a building. This is a dynamic event. It is not surprising then that many details seem to have escaped the observer when he compares the photographs with his first-hand experience. The observer perceives selectively and reacts to various visual stimuli.
The advantage of static photographic reproduction is that the details can be analyzed afterwards without having to try and remember them. The professional photographer of course has a great deal of expertise which an architect may lack. The architect does not have the equipment or the training. In spite of this some intresting possibilities are left open to him, such as photomontage in drawings and the inverse procedure, as well as the use of a drawing as a basis for a perspective drawing, etc.
Computer users have the additional possibility of scanning photographs, which permits image manipulation, the scaling down of objects, or other modifications.

Film and video

The observer experiences buildings by scanning them with his eyes. Film and video are the ideal media to capture this process and as such are excellent aids to analysing three-dimensional situations.

The disadvantage of film – the older of the two media – is that it has to be developed first before the results can be seen. Shots which cannot be used have to be edited out and replaced by new location shots.

The latest medium, video, has as good as ousted the film as an aid to representing the architectural environment. Video-recordings can be played back immediately and judged immediately; an unsatisfactory recording can be replaced by a better one.

Video cameras and video machines for home-use are of such a high quality and are so easy to operate that anybody can use them. Usually an ordinary VHS system will do. Only when a high-quality video recording is required – which is seldom the objective of the architect – should more professional equipment be used. This inevitably involves expert assistance.

The architect is generally not in the habit of using such video equipment. He probably knows little about the possibilities of the medium and rather relies on his own visual memory and experience. The idea of TV-productions or of written scripts quite possibly scares the architect and he might prefer to reach for his familiar camera. However, as pointed out, the documenting of the architectural environment by means of a video offers more opportunities. Traffic situations or the use of public areas can for instance be recorded and by using transposition the changing proportional relationship between buildings can be determined. The recordings can be analyzed immediately. A tape can be played as often as necessary and it is possible to freeze the image so that it can be analysed in detail.

The use of a video machine in the design process is technically complicated and will therefore not have a wide application if it is used in combination with a solar simulator and an enthescope – the observer can walk through a model – but it will usually only be used for larger projects with access to extensive funds. The recorded images could be used to present the scheme to the client.

A current development of interest to the architect is a process which combines video and computer. He will soon be able to make a decision and immediately analyze the effect on the scheme by means of simulation programmes which allow him to 'walk through' his design.

Index

COMPARATIVE CHART OF PRESENTATION TECHNIQUES

type and description	material used — paper: white / transparency / dyeline print / polyacetate film	slides / photographs / film	video tapes / floppy disk, disk, tape	available surface	1–10	10–30	≥30	text	drawings: pencil / ink / felt-pen / chalk	illustrations	photographs	prints	computer prints	computer plots	dynamic images
flip-over paper holder on base with solid background	white ● transparency ● dyeline print ●			A1 A1 A1	● ● ●	 ● ●		● ● ●	 ● ● ● ●					● ●	
blackboard				>A0	●	●	●	●	●						
glassboard				A0	●	●		●	●						
overhead projector / projection by means of reflection	transparency ● polyacetate film ●	slides ●[1] photographs ●[1]		A4/A3	●	●	●[2]	●	● ● ●		●[3]	●[3]		●[3]	
episcope / projection by means of incident light	white ● transparency ●	photographs ●		A4	●	●	●	●	● ● ●	●	●	●	●		
slide projector		slides ●		k.b. or 6×6	●	●	●	●	● ● ●	●	●	●	●		
slide projector in combination with daylight screen		slides ●		k.b. or 6×6	●			●	● ● ●	●	●	●	●		
film projector		film ●			●	●	●	●	● ● ●	●	●	●	●		●
video (monitor)		video ●			●	●		●	● ● ●	●	●	●	●		●
video (projector)		video ●			●	●	●	●	● ● ●	●	●	●	●		●
computer (monitor)			disk ●		●	●[1]		drawing	●[2] ●[1] ●	●	●				
hologram		slides ● photographs ● film ●			●						●	●			

126

advantages	disadvantages	remarks
high attention drawer in direct (descriptive, illustrative) use; use of pre-printed sheets	clarity dependent on writing and drawing skills and distance	for diagrams, drawings and text; good for direct writing and drawing, less when suspended; limited colour use with felt-pen; only contrasting colours should be used to improve clarity
high attention drawer	clarity dependent on writing and drawing skills	for diagrams, drawings and text; for direct writing and drawing; limited use of colour; only use contrasting colours to improve clarity
high attention drawer	clarity dependent on writing and drawing skills	for diagrams, drawings and text; for direct writing and drawing; limited colour use with felt-pen; only use contrasting colours to improve clarity
high attention drawer in direct (descriptive, illustrative) use; use of pre-printed sheets; suitable photocopies on transparency	clarity dependent on writing and drawing skills and familiarity with the equipment; poor tonal and colour contrast in projection	[1] only enlarged slides [2] dependent on the luminous flux intensity of the projector and darkened room [3] only on transparency/polyacetate film; limited use of colour with felt-pen use only contrasting colours to improve clarity; block in colours with adhesive film
projection of various kinds of printed surfaces possible; books etc.	poor luminous flux intensity of projector; limited surface of the original	darkened projection room required
excellent projection quality; useful slide cases		slide projectors are present 'everywhere'; cheap medium with excellent projection quality; no darkened projection room necessary;
darkened projection room not necessary	limited projection surface	can be set up everywhere in combination with automatic slide carroussel; continuous presentations are possible and thus very suitable for exhibitions; can be used in combination with sound equipment
dynamic image; excellent projection quality	dependent on cinematic and editing skills; expensive equipment	only for professional use; image and sound
dynamic image; non-professional equipment useful and affordable; video recorder available 'everywhere'; simple images and display	image quality dependent on TV monitor quality and screen size	continuous presentation possible and thus very suitable for exhibitions and for educational purposes; image and sound; can be used with computer; computer animation and simulation display
instruction for larger groups	image quality; darkened room necessary	average image quality; darkened room required
rapid image formation and picture switching; computer animation and simulation display; linking with video equipment; simple reproduction and processing by modem	image quality dependent on monitor quality and screen size	[1] with more than one monitor [2] illustrations and photographs should be input with the aid of computer peripherals image quality is dependent on the type of monitor and computer programme; acceptable images only produced by expensive monitors
strong illusion of space	limited use of colour; (still) limited production possibilities	in combination with the computer; in the experimental phase

Photographs

Pages 7, 8: Art History Documentation Centre of the State University of Utrecht.
Pages 17, 19, 56, 57, 60, 81, 82, 85, 86, 87, 88: the author.
Page 20: Archiphoto, Haarlem.
Pages 40, 115, 117 centre, 118, 121: Photography Department of the Civil Engineering Faculty of the University of Delft.
Page 109: Arcade O'Harris, Woerden.
Page 111: Grabowsky & Poort B.V., The Hague.
Page 112: Aerophoto, Schiphol B.V.
Page 113: Photography Department of the City Planning Department in The Hague.
Page 123: Fas Keuzekamp, Pijnacker.

Bibliography

Pierre Descargues, *Perspektief,* Andreas Landshoff, Amsterdam, 1976.

Koos Eissen, Erik van Kuijk, Peter de Wolf, *Produkt-presentatietekenen,* Delftse Universitaire Pers, Delft, 1984.

Robert W. Gill, *Rendering with pen and ink,* Thames and Hudson, London, 1979.

Johannes Itten, *Kunst en Kleur. Een kleurenleer over het subjektief beleven en objektief zien van kleur als weg naar de kunst,* Cantecleer, De Bilt, 1973.

Karlerik Janson, *De Perspectief. Leidraad bij het gebruik van het Perspektief Rastersysteem Janson,* Art Material Import, Kaltenkirchen, West Germany, 1982.

Ronald B. Kemnitzer, *Rendering with Markers. Definitive techniques for designers and architects,* Watson-Guptill Publications, New York, 1983.

John Moran R.A., *Perspective Methods. Third dimensional graphics,* Chicago, Illinois, no date.

Dr. J.L. Ouweltjes, *Het zien van kleuren,* Kluwer Technische Boeken, Deventer-Antwerpen, 1978.

Dick Powell, *Ontwerppresentatietechnieken. Een gids voor het visualiseren van industriële ontwerpen,* Gaade Uitgevers Veenendaal, 1986.

Dr. Ir. C.J.M. van der Ven, 'Van beeld tot maat/1. Schaal in de optische waarnemeing', in *Intermediair,* 16e jaargang 1980, no. 17.

Dr. Ir. C.J.M. van der Ven, 'Van beeld tot maat/2. Schaal in de optische waarnemingen', in *Intermediair,* 16e jaargang 1980, no. 18.

John White, *The birth and rebirth of pctorial space,* Faber and Faber, London, 1972[2].

About the author

Koos Eissen has been a lecturer in freehand drawing in the History, Media and Theory Department of the Faculty of Civil Engineering of the University of Delft since 1975. He is also lecturer in freehand drawing at the Faculty of Industrial Design of the University in Delft and is a visiting lecturer at the Royal Academy for Visual Arts in The Hague.

Contents

Chapter 1
Getting Started

This book is for people who are new to computers – perhaps you have just bought your first home PC, or started an introductory course at college or in your workplace.

It aims to give you a 'taster' of what you can do on a PC and give you the confidence to move on and find out more.

Your computer

Your computer will have a main system unit that incorporates a hard disk drive, a CD-ROM drive, a floppy disk drive and the on/off switch. It will also have a screen, a keyboard and a mouse. In addition most new PCs are supplied with speakers and a printer.

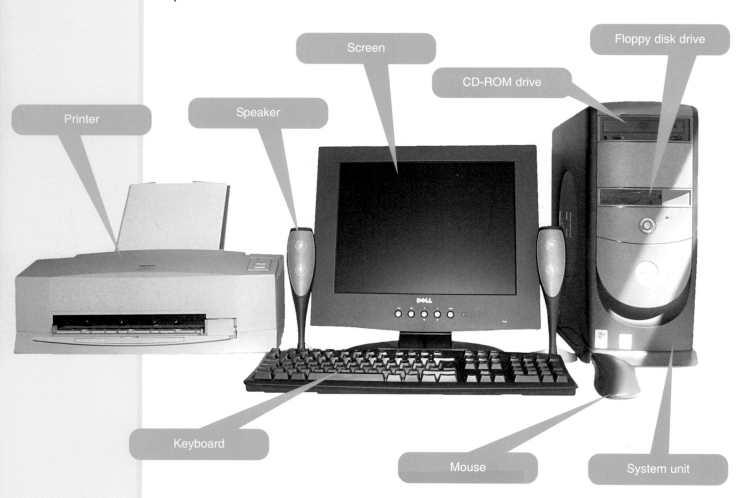

Printer

Speaker

Screen

CD-ROM drive

Floppy disk drive

Keyboard

Mouse

System unit

Switching on

Check that the floppy disk drive is empty and switch on the power.

▶ Press the power switch on the front of the system unit. Also remember to switch on the screen and the printer.

The system will immediately run a power-on self-test to check that everything is working OK.

Wait for the screen to stop changing. It should end up with some small symbols (called icons) and a coloured background – this is called your desktop.

Icons

Office toolbar

Figure 1.1: The Windows XP desktop

Depending on how your computer has been set up you may see an Office toolbar – this provides shortcuts to some programs.

Changing the background

If you don't like the desktop background you can easily change it.

If you are not used to using the mouse, wait until you have completed the rest of this chapter then have a go.

- Right-click the mouse on the desktop picture.

- In the menu that appears left-click the Properties option.

- In the Display Properties box that appears click on the Background tab.

- Scroll down the list and click on a background. You will see a preview of what it looks like.

- When you find one you like, click OK.

Figure 1.2

Using the mouse

The mouse is used to give your computer instructions and you need to learn how to control it. It's a bit like learning to ride a bicycle – once you can do it, it's easy.

▷ If you are right-handed hold the mouse like this:

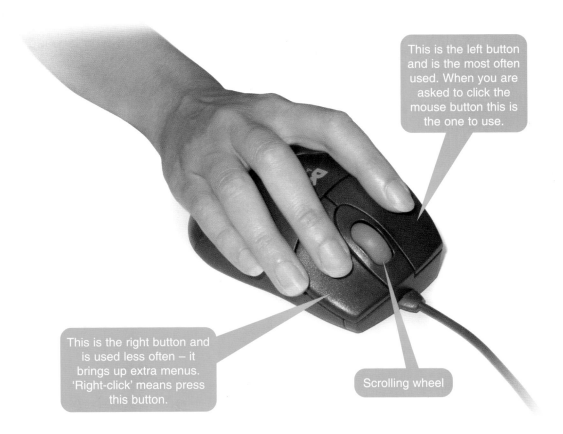

This is the left button and is the most often used. When you are asked to click the mouse button this is the one to use.

This is the right button and is used less often – it brings up extra menus. 'Right-click' means press this button.

Scrolling wheel

Tip:
If your mouse has three buttons just ignore the middle one.

Tip:
Some types of mouse have a scrolling wheel (or button) - more about this later.

Figure 1.3

If you are left-handed, your index finger will be on the right button.

Mouse practice

▷ Push the mouse around. You will see that it moves an arrow-shaped pointer around the screen.

▷ Click the left button – you can hear it click.

We will use a games program that is supplied free with Windows to practise using the mouse.

▷ Move the mouse pointer so that it is positioned over the button labelled Start in the bottom left-hand corner of your screen.

▷ Click the left mouse button. A list will appear.

▷ Move the mouse pointer over All Programs and click again.

▷ Move the mouse pointer over the word Games and click.

▷ Move the pointer across to Freecell and click again.

Tip:
In Windows 2000, click **Programs**, **Accessories**, **Games, Freecell**.

Note:
You will probably have a different list of programs from this.

Figure 1.4: Selecting a program

Freecell is a card game that you can play on the computer. When the program first appears on your screen it will appear in a window like this.

Figure 1.5: The Freecell window

The **Title bar** contains the title of the program (Freecell in this case) and there are three small buttons on the right.

Figure 1.6: Window buttons

Move your mouse pointer over the **Minimize** button and click with the left mouse button.

<div style="float:right">

Tip:
Hover the mouse over each button and a **Screen Tip** tells you the name of the button.

</div>

Don't panic - the window disappears, but not completely. Look at the bottom of the screen and you should see a bar labelled FreeCell. This appears on the Status bar which is another feature of all Windows programs – it shows you which programs are currently running.

Figure 1.7: The Status bar

▷ Click on this bar and the window will reappear.

▷ Now click on the Maximize button and the window will get larger.

▷ Finally try out the Close button – this closes the window and closes the program too.

Now you are back where you started.

▷ Practise going back to the Start menu and opening up the Freecell program again.

You should now have a window like Figure 1.5 on the screen. The line below the Title bar is called the menu bar.

Game Help Cards Left: 0

Figure 1.8: The Menu bar

This bar has labels that when clicked, produce drop-down menus with options to choose from. Different programs will have different menus: in this case Freecell has only two.

▷ Move the mouse pointer over the word Game and click the left mouse button.

Tip:
If the instructions just say click, it means click the left mouse button.

A drop-down menu like this will appear.

Figure 1.9: The Game menu

Move your pointer down and click on New Game.

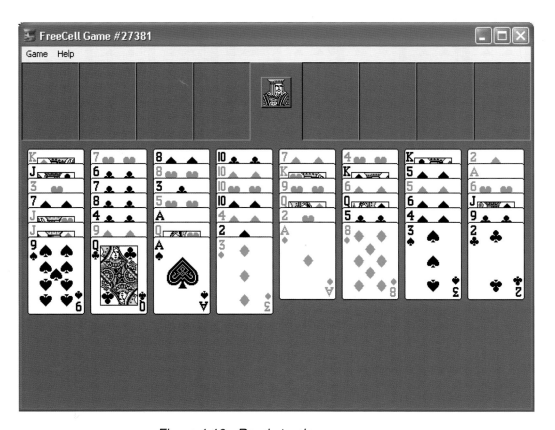

Figure 1.10: Ready to play a new game

Playing the game

The object of FreeCell is to move all the cards into the home cells, using the free cells as placeholders. You have won when you have made four stacks of cards on the home cells, one for each suit, stacked in order of rank, from lowest (ace) to highest (king).

 To move a card, click the card you want to move, and then click where you want to move it. You can move cards to a different column, a free cell or a home cell.

Moves to another column must be made in order of highest card (king) to lowest (ace), in alternating suit colours. Moves to a home cell must be made in order of lowest to highest, in the same suit.

Tip:
You can move several cards to a new column if they are stacked in order correctly.

Figure 1.11: The game in progress

Using Help

If you would like to get more detailed instructions on how to play FreeCell, or you want to look up recommended strategies and tips, use the Help menu. All Windows programs have a Help menu and this can be invaluable if you don't have a reference book or an experienced user around to ask!

▶ Move the mouse pointer over the word Help and click with the left mouse button. Click on Contents.

A Help window will appear like this.

Figure 1.12: The Help window

Tip:
You can also access the **Help** system by pressing the key labelled **F1** on the keyboard.

▶ Click on one of the options in the left-hand part of the window and the information will appear on the right-hand side.

▶ To return to the game, click the Close window button.

▶ If you want to play another game click on New Game from the Game menu.

▶ If you want to close Freecell, either click on Exit from the Game menu or click the Close button.

Chapter 2
Writing a Letter

A PC can be very useful for typing documents of one kind or another. One of the most frequently-produced documents is a formal letter.

The software used to produce written documents is called word processing software. One of the most common word processing packages is Microsoft Word.

Opening Word

Tip:
In Windows 2000 click **Start**, **Programs** and then **Microsoft Word**.

Open Word in a similar way to opening the Freecell game:

 Click on Start, move up the list to All Programs and across to Microsoft Word.

Tip:
If you cannot see Word in the list, click the down arrow at the bottom of the list and more options will appear.

Figure 2.1: Opening Word

Word will open with a screen like this:

Figure 2.2

This program has a title bar and a menu bar (but it has 9 menus this time). It also has toolbar buttons, which are buttons you can click with the mouse to carry out actions instead of selecting an option from one of the menus.

The Task pane opens and closes automatically depending on what you are doing. You can close the Task pane at any time by clicking the Close icon (**X**) in its top right-hand corner.

 Close the Task pane.

Typing practice

Tip:
If you want to learn how to touch-type, there are plenty of books and CDs available to teach you.

The large white area is where you are going to type. You will see a flashing bar in the top left corner called the insertion point – this is where the letters will appear as you type.

You may not be familiar with using a keyboard and you will find it rather slow at first – but it's surprising how fast you can get with two fingers!

Here are some of the keys you will need to use.

Figure 2.3: A standard keyboard

▶ Press each of the top row of letter keys.

<p style="text-align:center">qwertyuiop</p>

▶ Press the Enter key to move to a new line.

▶ Press the Caps Lock key and then type the same sequence of keys again. The letters should all appear as capitals.

<p style="text-align:center">QWERTYUIOP</p>

▶ Press the Enter key to move to a new line.

▶ Press the Caps Lock key to turn it off.

▶ Press each of the numbered keys on the top row.

<p style="text-align:center">1234567890</p>

▶ Press the Enter key to move to a new line.

▶ Press the numbered keys again, but this time keep one finger on one of the Shift keys.

<p style="text-align:center">!"£$%^&*()</p>

This time the symbols above the numbers are displayed. So, holding down the Shift key while you press another key will display either the symbol at the top of the key, or a capital letter (like the Caps Lock key did).

Your screen should now be looking something like this.

Qwertyuiop
QWERTYUIOP
1234567890
!"£$%^&*()

Figure 2.4

Tip:
The **Caps Lock** key is called a toggle key - if you press it a second time it goes back to lower case characters.

Tip:
If you type the wrong letter press the **Backspace** key to rub it out.

Tip:
If you press **Enter** in the middle of a line by mistake, some of your text will move to the next line. Press the **Backspace** key to delete the **Enter** character.

Tip:
Word will automatically capitalise the first letter. You will also see a red wavy line because it thinks it is a mispelt word – just ignore this.

The insertion point will be flashing after the last letter you typed. If you move the mouse around, the pointer moves around the screen. The pointer looks different depending on where it is.

When the pointer is in the ruler it is shaped like an Up arrow pointing left

When the pointer is in the left margin it is shaped like an Up arrow pointing right

When the pointer is in the text area it is shaped like an I beam

Figure 2.5

Try clicking with the left mouse button in the middle of the text. The insertion point will move to where you clicked and if you start typing the letters will appear at that point.

Warning:
If you type some new letters and they overwrite the existing text try pressing the **Insert** key on the keyboard to return you to insert mode.

Deleting text

▶ Practise using the Backspace key to delete characters before the insertion point and the Delete key to delete characters after the insertion point.

You could delete all of the text you have typed so far using these two keys, but here's a quicker way.

▶ Position the pointer in the left margin next to one of the lines of text.

▶ Double-click the left mouse button. The line of text next to the pointer should look highlighted, white text on a black background. We call this selected text.

▶ Press the Delete key and the selected text should disappear.

▶ Repeat this for each line of text. You should now have a blank screen.

▶ Practise typing the following sentences, pressing the Space bar to create a space between words. When you reach the end of a line, Word will automatically start a new one for you. You need to press the Enter key only when you want to force a new line.

> **Juliet and Kirk were quite vexed to be leaving Zanzibar.**
>
> **We suggest you visit our headquarters in New York whenever you find the time.**
>
> **The role of the salesman is to negotiate the maximum price.**
>
> **The amazing vegetables grown by Joyce Thornton quickly earned her the top seven awards at a Produce Show in Essex.**
>
> **Items Z1879, V5018 and R1428 were missing from the catalogue.**

Practise deleting individual characters using the Backspace and Delete keys and deleting complete rows by selecting them and pressing Delete – make the following changes:

▶ Change the name Juliet to Julie.

▶ In the second sentence replace the words find the time with can.

▶ Delete the third sentence completely.

▶ In the fourth sentence change the name Joyce to Jayne.

▶ In the fifth sentence insert the word new before catalogue.

▶ Delete everything on the screen.

Typing the letter

▶ Click at the top left of the page.

▶ Practise typing in the following letter. When you reach the end of a line Word will automatically start a new one for you, but remember to press the Enter key whenever you want to force a new line.

Tip:
If your screen suddenly goes blank it may be because you have accidentally scrolled down the page. Try dragging the scroll box back up to the top of the scroll bar.
If your mouse has a scroll wheel you can use it to move back to the top of the document.

Reminder:
There's always the Help menu if you get really stuck.

Figure 2.6

▶ Check it over on the screen and correct any mistakes using the techniques you have just been practising.

Now move on to the next chapter to save all that hard work!

Chapter 3
Saving

After you have created your letter you will probably want to save it. This may be because you want to do some more work on it at another time or you may want to save it so that you can print it out later.

All the documents you create on your PC are referred to as files. These files have to be given names that can be quite long (up to 255 characters) so it is a good idea to use meaningful file names that you can easily find.

As you use your computer more and more you will have lots of files stored on your hard drive. It is extremely important to keep your work organised so that you can go to it quickly.

Files are organised into folders that are also given names and which can contain subfolders. One very important folder that is set up automatically for you is My Documents. This is where Windows expects you to create your own subfolders to store your work. For example:

Tip:
You will see the **My Documents** icon on the desktop

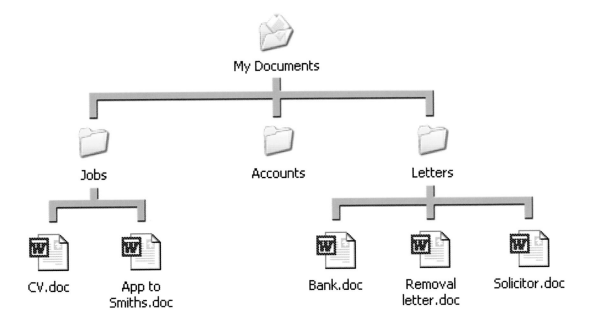

Creating a new folder

So, before you save your work, let's set up a new folder to store it in:

▶ Do not close Word – leave it open on the screen.

▶ Click the Start button to display the Start menu.

Figure 3.1: Starting My Computer

▶ Click on My Computer.

Figure 3.2

▶ Click on My Documents in the Other Places section.

20

Figure 3.3

The folders that you currently have within My Documents will be displayed on the right.

 Click on Make a new folder in the File and Folder Tasks section.

 In the text box that appears next to the new folder icon type in the name Letters.

Figure 3.4: Naming the new folder

▷ Press Enter and close My Computer by clicking the Close Window icon in the top right-hand corner of the window.

Word should still be on your screen with your letter displayed. You can now save the letter in your new folder.

▶ Select File, Save As. The Save As box will appear. Now you need to find your folder and give your document a name.

▶ Click the arrow to the right of the Save in box and select My Documents.

Figure 3.5

▶ Double-click the Letters folder.

Your folder appears at the top of the box, ready for you to save your work into it.

▶ Double-click at the beginning of the box labelled File name and type a title for your letter e.g. Removal letter.

Figure 3.6: Saving the letter

▶ Click Save.

The box will disappear and your work will be saved. Look at the title bar above your letter and the name should have appeared there.

▶ Close Word by clicking the Close icon.

Tip:
Your letter will disappear from the screen - it has been saved on your disk drive.

Copying, moving and deleting files and folders

You can use My Computer to copy, move and delete your files and folders. We will practise copying the file Removal letter into another new folder and then deleting the original.

▶ Open My Computer and click on My Documents.

▶ Click on Make a new folder to make a new folder as you did before and name this folder OurMove.

▶ Double-click the Letters folder and click the file Removal letter.

Figure 3.7

▶ Click Copy this file.


Tip:
It is recommended that beginners use this procedure to move files. Make a copy first and delete the original only when you are sure it has copied successfully.

23

In the Copy Items window that appears click on the OurMove folder and then click Copy.

Figure 3.8

Click on My Documents and then double-click the OurMove folder. You should see a copy of the letter stored in this folder.

Figure 3.9

Now we'll delete the original version of the letter from the Letters folder.

▶ Click on the Back arrow to return to My Documents.

▶ Double-click on Letters and then click on Delete this file.

Figure 3.10

▶ A warning message will appear asking you if you are sure you want to delete the file.

▶ Click Yes to confirm the delete.

The Letters folder should now be empty.

▶ Close My Computer by clicking the Close Window icon.

Searching for files

If you lose a file you can use the Search facility in My Computer to find it again. We will ask My Computer to find the letter for us again.

 Open My Computer and click the Search button.

Figure 3.11

 In the box on the left click on Documents.

Figure 3.12: Searching for a file

▶ Type in the name of the file we are looking for i.e. Removal Letter and click Search.

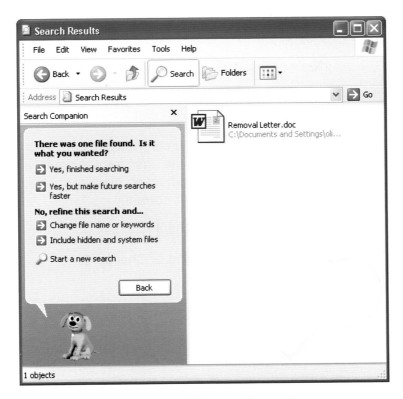

Figure 3.13: The search results

It has found the file we were looking for.

▶ Click on Removal Letter and details of the file will be displayed in the bottom-left of the window.

▶ Double-click Removal Letter and the file will open.

▶ Close the letter and Word by clicking the Close icon.

Chapter 4
Printing

If you have a printer connected to your PC you can now print out your letter on paper. There are different types of printer but the chances are yours will be either an ink-jet printer or a laser printer. Refer to the instruction manual to check that you have switched it on and loaded some A4 paper correctly.

Now re-open the letter you saved in the last chapter.

▶ Open Word as you did at the beginning of Chapter 2.

▶ Select File, Open.

This list shows your recently used Word files. If it's in the list you can click it here to open it.

Figure 4.1: Opening a document

▶ In the dialogue box click on Removal Letter and click Open.

Chapter 5
Making a Poster

Sometimes the documents you produce need to be more eye-catching. Perhaps you need posters to advertise the local village fete or a meeting of the local residents' association or you might want to advertise something for sale.

Whatever it is, you need to use more of the features available with your word processing package to create different sizes, styles and colour of text together with colourful pictures to attract the readers' attention.

In this example we will create an advertisement to display in your car window in an effort to sell it. When completed it should look something like this:

Figure 5.1: The completed poster

Starting the advertisement

This time it would be better to print the advertisement on landscape paper, so that it will fit in the car window.

▶ Open a new Word document by clicking the New Blank Document button on the Standard toolbar.

▶ Select File, Page Setup and click the Margins tab at the top.

▶ Click Landscape orientation and then click OK.

Figure 5.2

When you typed the letter in Chapter 2, all the text was lined up automatically down the left margin – this is called left-aligned text. If you look at the car advertisement you can see that all the text (except for the telephone number line) is centred on the paper. In Word Processing programs text can be left-aligned, centred or right-aligned. You do this by using three buttons on the Formatting toolbar.

Figure 5.3: Text alignment buttons

▶ Click the Center button on the Formatting toolbar.

▷ Close the Task pane (**X**).

The insertion point should flash in the middle of the page.

▷ Type in the words For Sale.

These words need to be much larger so that they will be noticed by passers-by.

▷ Click the mouse pointer in front of the first letter. Keep the left mouse button pressed down and drag the mouse over the two words. A coloured background appears behind the words – this is called selecting text.

Figure 5.4

▷ Click the arrow shown in Figure 5.4 and from the list that appears click on size 48.

The text should have become much larger.

▷ Click at the end of the text to deselect it (the black background will disappear).

▷ Press the Enter key on the keyboard to move to a new line.

Tip:
Always use the **Center** button - never use the Space bar to go to the middle of the page.

Inserting a picture

Now we will insert a picture of a car. Word comes with a small collection of clip art that you can use in your documents. Clip art is simply a selection of pictures and drawings that have been drawn by professional artists and collected together.

▶ Select Insert, Picture, Clip Art.

Figure 5.5

▶ In the Search text box that appears in the Task pane type cars. Click the Search button. A gallery of pictures will appear for you to choose from.

▶ Click on the picture you want to insert and it will appear in your poster.

Figure 5.6

Make sure the picture is selected with the black handles visible. If it is not selected then click it.

You can make the picture bigger or smaller without changing the proportions by dragging any of the corner handles.

▶ Move the mouse pointer over the bottom right handle until it is shaped like a diagonal two-headed arrow.

▶ Click and hold down the left mouse button.

▶ Drag downwards and outwards. The car will get bigger.

▶ Drag upwards and inwards and return the car to its original size.

▶ Click next to the car so that the black handles disappear. Press Enter to move to a new line.

▶ Select File, Save As and save the advert as CarPoster in your My Documents folder.

Note:
This is called sizing the picture.

Completing the text

▷ Close the Task pane.

▷ Type in the words LX Vere Saloon.

▷ Highlight this line of text and change the size to 72.

B —— ▷ While the text is still highlighted, click the Bold button on the Formatting toolbar.

The line of text should now be large and bold.

▷ Press Enter to move to a new line and type in the price line £3995 o.n.o.

I —— ▷ Highlight the line and change it to size 26 and bold. This time click the Italic button too.

▷ Click at the end of the text to deslect it.

▷ Press Enter and type in the next three lines as shown in Figure 5.1. Make the text size 22.

≣ —— ▷ Move to the next line and click the Left-align button on the Formatting toolbar.

▷ Press the Tab key on the keyboard which will move the insertion point a little from the left margin.

Tab

Tip:
Tab is next to
Q on the
keyboard.

▷ Type in the Telephone number line in size 18, not bold.

LX Vere Saloon

£3995 o.n.o
1979 V Registration
100,000 miles – excellent condition
1 careful lady owner
Telephone 0123 34567 (after 6.00pm)

 Click the Print Preview button on the Standard toolbar to see how the advertisement is coming along.

Figure 5.7: A preview of the poster

Remember that in Print Preview you can click the left mouse button to zoom in and magnify the page. Click again to zoom out.

 Click Close to return to the document.

 If you are happy with your work so far then save it again. This time click the Save button on the Standard toolbar.

Changing the page margins

Margins are the white spaces to the top, bottom, left and right of a page. On our advertisement the top and bottom margins seem too deep. We will make them smaller to give us more room on the page.

▶ Click the Close button on the Print Preview toolbar.

▶ Select File, Page Setup.

▶ Enter 2.0 cm for the top and bottom margins.

Figure 5.8: Changing margins

If you look at the document in Print Preview again you will see we have created some extra space at the bottom of the page.

Changing the style of text

In the completed advertisement shown in Figure 5.1 you will see that the first line **For Sale** is emphasised by being in a different font (style of lettering) and colour.

▶ Highlight the words **For Sale**.

▶ Change the font to **Comic Sans MS** by clicking on the arrow shown below and scrolling down the list of fonts. Click on **Comic Sans MS**.

Figure 5.9

▶ To change the colour of the letters, click the arrow next to the **Font Color** button and select a colour.

Figure 5.10: Changing the font colour

▶ Practise changing the size, colour and style of different lines of text. Insert some extra lines if you think it needs spacing out more.

▶ Use **Print Preview** to see how you have improved the document.

▶ Now save your advertisement and print it out.

▶ Close Microsoft Word.

For Sale

LX Vere Saloon

£3995 o.n.o

1979 V Registration
100,000 miles – excellent condition
1 careful lady owner

Telephone 0123 34567 (after 6.00pm)

Figure 5.11

Chapter 6
Household Accounts

What is a spreadsheet?

Spreadsheets help you to organise numbers and words into neat columns and rows. Some special features allow you to perform calculations on the numbers, sort lists alphabetically or numerically and create graphs and colourful charts from your spreadsheets.

Spreadsheets are used by most businesses working with financial data. They are often used in the home too, for household accounts and planning budgets – for the family holiday perhaps. Different figures can be entered and the effect of the changes will be calculated automatically.

There are many different spreadsheet packages that you can purchase to run on your PC. This example uses Microsoft Excel 2002.

Fact:
Microsoft Word and Microsoft Excel are supplied as part of Microsoft Office.

started

icrosoft Excel by selecting it from the list of programs on the Start

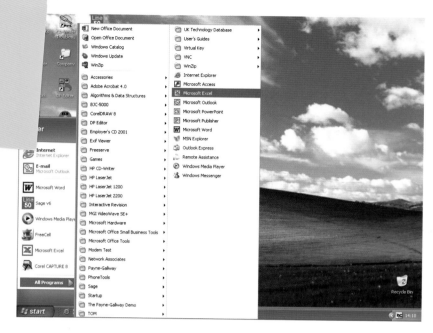

Figure 6.1: Starting Excel

Your screen should look like the one below:

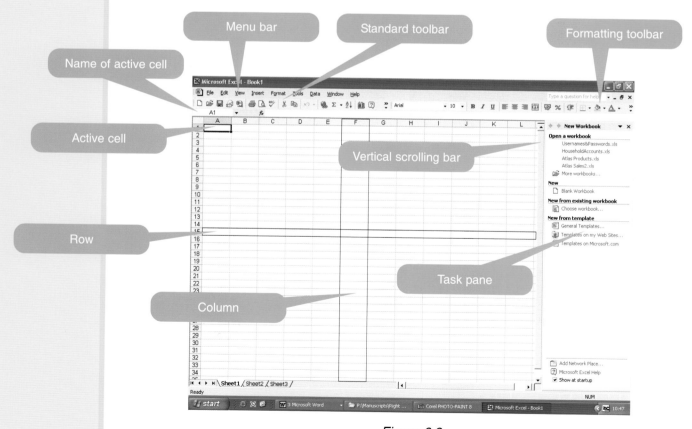

Figure 6.2

On the opening screen you can see a menu bar and toolbar rather like you used when you were word processing earlier.

The main part of the screen is divided into a grid of rows and columns. The columns are labelled A, B, C etc., and the rows are labelled 1,2,3 etc.

Each box made by the grid is called a cell and is referred to by its column letter and row number. The reference of the cell in the top left hand corner is A1, because it is in column A and row 1.

There are lots more cells in the spreadsheet that you can't see at the moment.

▷ Drag the scroll bars to see some of the other empty cells.

▷ Drag the bars back again so that cell A1 is in the top left hand corner as shown above.

When you open a new spreadsheet, cell A1 is highlighted and we call that the active cell. When you start typing, the letters or numbers will appear in this cell.

You can move about the spreadsheet to make any of the cells active in several different ways. Try these out:

▷ Move the pointer using the mouse and click the left mouse button in the cell you want.

▷ Press the Tab key on the keyboard to move to the next cell to the right.

▷ Use one of the arrow keys on the keyboard to go up, down, left or right.

Entering text

Let's set up a spreadsheet for the household accounts.

We will record all incomings and outgoings over a six-month period. The spreadsheet will calculate the remaining balance each month and a cumulative balance over the six months.

▶ Close the Task Pane on the right of the screen by clicking its Close icon.

▶ Click in cell A1 to ensure that this is the active cell.

▶ Type the heading Accounts.

▶ Now click in cell A3 and type the label Incoming.

▶ Click in cell B2 and type January.

▶ Press the right arrow key to move to cell C2 and type February.

Now highlight cells B2 and C2 and drag the small Fill handle in the bottom right-hand corner to cell G2. Excel understands that you are listing the months of the year and fills them in automatically for you

	A	B	C	D
1	Accounts			
2		January	February	
3	Incoming			

Drag the fill handle

Figure 6.3

▶ Type the remaining items into cells A3 to A24 as shown in Figure 6.4.

	A	B	C	D	E	F	G
1	Accounts						
2		January	February	March	April	May	June
3	Incoming						
4	Salary						
5	Family allowance						
6	Totals						
7	Outgoing						
8	Mortgage						
9	Council tax						
10	Gas						
11	Electricity						
12	Telephone						
13	TV licence						
14	Satellite TV						
15	Car insurance						
16	Car tax						
17	Food						
18	Clothing						
19	Entertainment						
20	Petrol						
21	Totals						
22							
23	Balance each month						
24	Cumulative balance						

Figure 6.4

Editing data

The heading on the spreadsheet should have been Household Accounts, not Accounts. There are several ways of putting this right but we will try one of the simplest.

▶ Click in A1 that contains the heading Accounts. You will see that the text also appears in the formula bar.

Figure 6.5

Click in the formula bar before the letter A.

▶ Type in the word Household, followed by a space. You will notice that the letters appear in cell A1 at the same time.

▶ Press Enter to register the change.

Deleting data

Suppose we decide that we do not want to include entertainment and petrol in the list of outgoings (cells A19 and A20). We can delete them.

▶ Click in cell A19, keep your finger down on the left mouse button and drag down into cell A20 to select the two cells.

	A	B
1	Household	Accounts
2		January
3	Incoming	
4	Salary	
5	Family allowance	
6	Totals	
7	Outgoing	
8	Mortgage	
9	Council tax	
10	Gas	
11	Electricity	
12	Telephone	
13	TV licence	
14	Satellite TV	
15	Car insurance	
16	Car tax	
17	Food	
18	Clothing	
19	Entertainment	
20	Petrol	
21	Totals	
22		
23	Balance each month	
24	Cumulative balance	

Figure 6.6: Selecting cells

▶ Press the Delete key on the keyboard.

The contents of cells A19 and A20 should have disappeared.

Remember that if you accidentally delete something there is no need to panic. Suppose we decide we *would* like to include entertainment and petrol in our calculations: we now need to undo the deletion.

▶ Select Edit, Undo clear and the text should reappear.

Tip:
You will notice that when you select spreadsheet cells, the first one in the selection remains white.

Making columns wider

Let's make column A wider so that all of the contents fit in without spilling over into column B.

▶ Point between the column headers (see Figure 6.9) for column A and B.

▶ When the pointer changes to a left- and right-pointing arrow (see Figure 6.7), click and drag to the right.

Figure 6.7: Sizing a column

The spreadsheet should look clearer now.

Figure 6.8: The spreadsheet so far

Reminder:
Use the Help menu or press F1 for help if you run into problems.

49

Inserting and deleting rows and columns

We can delete the whole of row 22 so that there is no gap between Totals and Balance each month.

 Right-click the row header for row 22 and select Delete Row from the shortcut menu.

The next line of text moves up to row 22.

Tip:
You can delete columns in the same way.

Figure 6.9: Deleting a row

 Use the Undo button to bring the blank line back.

Inserting rows and columns is also very simple. Let's insert another row in between rows 6 and 7.

 Right-click the row header for row 7 and select Insert from the shortcut menu.

A new row is automatically inserted.

 Insert a new row between rows 21 and 22 and type Holidays in cell A22.

Inserting the data

Now we will enter the data shown in Figure 6.11. When the same entry is repeated in several cells you can use the Fill handle to speed up the data entry, for example:

▶ Click in cell B4, enter the value 1250 and press Enter.

▶ Click on cell B4 again and drag the Fill handle to cell G4 to repeat the value across the row.

	A	B	C	D
1	**Household Accounts**			
2		January	February	March
3	Incoming			
4	Salary	1250		
5	Family allowance			

Drag the Fill handle to cell G4

Figure 6.10

▶ Use this technique to enter the rest of the data.

	A	B	C	D	E	F	G	H
1	**Household Accounts**							
2		January	February	March	April	May	June	
3	Incoming							
4	Salary	1250	1250	1250	1250	1250	1250	
5	Family allowance	60	60	60	60	60	60	
6	Totals							
7								
8	Outgoing							
9	Mortgage	300	300	300	300	300	300	
10	Council tax	75	75	75	75	75	75	
11	Gas	30	30	30	30	30	30	
12	Electricity	25	25	25	25	25	25	
13	Telephone			120			120	
14	TV licence	110						
15	Satellite TV	20	20	20	20	20	20	
16	Car insurance		180					
17	Car tax		120					
18	Food	350	350	350	350	350	350	
19	Clothing	50	50	50	50	50	50	
20	Entertainment	100	100	100	100	100	100	
21	Petrol	60	60	60	60	60	60	
22	Holidays					800		
23	Totals							
24								
25	Balance each month							
26	Cumulative balance							
27								

Figure 6.11

Tip:
When you copy using Auto Fill, you will see a smart tag

Just ignore this at the moment.

Note:
Change these to match your incomings and outgoings if you wish.

Saving your work

▶ Select File, Save As.

A screen will be displayed rather like the one that you used to save your word processing documents.

▶ Make sure that you are in the correct folder.

▶ Type in a meaningful filename, for example HouseholdAccounts.

▶ Click Save.

Figure 6.12: Saving the spreadsheet

Using formulae

Now for the fun part – entering some formulae so that Excel will perform the calculations automatically for you.

First we need to calculate monthly totals for incoming and outgoing items.

▶ Click in cell B6 and press the AutoSum button on the Standard toolbar. ——————— Σ

Excel guesses which cells you want to sum. Your screen will look like this:

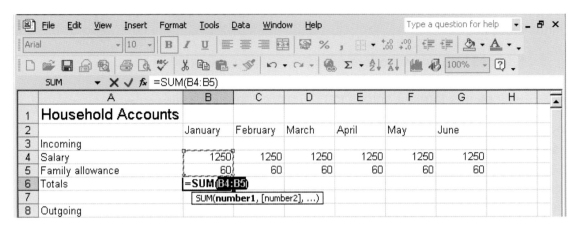

Figure 6.13

▶ Press Enter. The answer appears.

▶ Copy this formula to cells C6 to G6 using the Fill handle.

If we try to use AutoSum in cell B23 to total the outgoings for January it doesn't work because there are some empty cells in the column above. We will have to enter a formula from scratch.

Formulae are entered using cell references and are always preceded by the equals sign (=).

They use the following mathematical symbols:

+	Add
-	Subtract
*	Multiply
/	Divide

We could type =B9+B10+B11 and so on into cell B23, but this would be a very long formula. Instead we can use the Sum function which AutoSum automatically used in Figure 6.13.

> Click in cell B23 and type =Sum(B9:B22). This means we want to add up the contents of cells B9 to B22.

> Press Enter. The answer will appear.

> Use the Fill handle to copy the formula to cell G23.

In Row 25 we want to calculate the balance we have left each month (i.e. Incomings minus Outgoings).

> In cell B25 enter the formula =B6-B23 and press Enter.

> Copy this formula across to G25 using the Fill handle.

To produce the cumulative balances in row 26 we need to keep adding up the balances from each month.

> In cell B26 enter the formula =B25 and press Enter.

> In cell C26 enter the formula =B26+C25 and press Enter.

> Copy the formula in cell C26 across to cell G26. Have a look at Figure 6.13 – does yours look the same?

Figure 6.14

54

Formatting the spreadsheet

You will see that text always appears to the left in a spreadsheet cell (left justified) and numbers appear to the right (right justified). Let's right-justify the headings above the currency cells so that they line up, and make the text bold.

The spreadsheet would look better if the months in row 2 were right-aligned like the numbers.

▷ Select cells B2 to G2 and click the Align Right button on the Standard toolbar.

▷ While the cells are still selected, click the Bold button.

▷ Make the labels in cells A1, A3, A6, A8, A23, A25 and A26 bold.

▷ Make cells A6 and A23 right-aligned.

Cells B6 to G6 and cells B23 to G23 need a thick top and bottom border.

▷ Highlight cells B6 to G6.

▷ Click the arrow to the right of the Borders button on the Formatting toolbar.

▷ Click the Top and Bottom Border option.

▷ Repeat for cells B23 to G23.

Figure 6.15: Adding borders

Tip:
You can select non-adjacent cells by clicking in the first cell and then keeping your finger on the **Ctrl** key as you click the others.

55

The contents of cell G26 equals the balance remaining after the six-month period. We'll shade this cell to make it stand out.

▷ Click in cell G26.

▷ Click the arrow to the right of the Fill Color button on the Formatting toolbar and choose a colour.

▷ If the number is now difficult to see then use the Font Color button on the Formatting toolbar to change its colour.

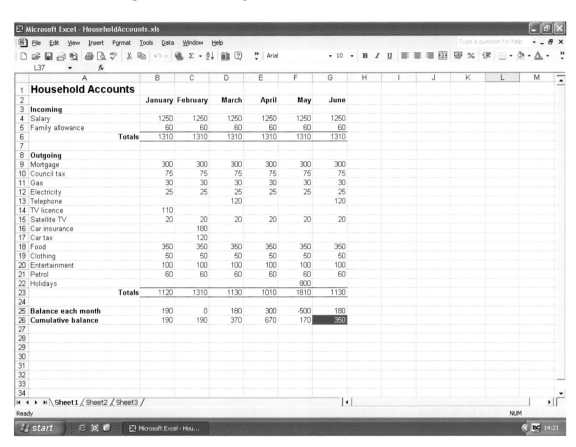

Figure 6.16: The completed spreadsheet

What if?

Now you can use your spreadsheet to see how your financial situation would change under different circumstances.

▷ Try changing the value of cells B20 to G20 to 75, to see how much better off you would be at the end of the six months if you economised on your entertainment spending.

▷ What is the most expensive holiday you could afford? (Try increasing the value in cell F22 and watch for your final balance in cell G26 approach zero.)

Tip:
If you want to learn more about Microsoft Excel look out for *Excel 2002 Right from the Start*.

Chapter 7
Surfing the Internet

Introduction to the World Wide Web

The Internet is a huge number of computers – including yours – connected together, all over the world. By using the Internet you can look up information on any subject you can imagine, or send and receive messages through e-mail.

In this chapter we will concentrate on surfing the World Wide Web – the fastest-growing area of the Internet, made up of millions of web sites.

Every web site consists of one or more documents called pages. A home page is the first page of a web site that serves as an introduction to the whole site.

Figure 7.1: The WWF home page

Pages on the World Wide Web are different from the pages you find in books. A web page doesn't have a set page size and can be short or long. When you print one web page, you could end up with several pages of A4 paper. Also instead of page numbers, every page on the web has its own address, called a Uniform Resource Locator or URL.

Getting Started

The program you use to surf the World Wide Web is called a Browser and one of the most popular is Microsoft Internet Explorer. To load it:

 Double-click on the icon for Internet Explorer.

 Or click Start at bottom left of the screen, and then click All Programs, then click Internet Explorer.

 You may see a dialogue box asking you if you wish to connect. If so, click Connect. (You may have to enter a username and password provided by your ISP.) An Internet page will appear on your screen – probably the one that the manufacturer of your computer has set as a default.

You can go to a different address by typing in a new URL or address.

 Click in the address box at the top of the window – the text will be highlighted.

Tip:
An **ISP** - Internet Service Provider - is a company that connects you to the Internet. Examples include Freeserve, AOL and BT.

Figure 7.2

 Type in **www.guardian.co.uk** and click Go.

Now your screen should look something like the one below. This is the web site of the Guardian newspaper. You will obviously be looking at it on a different date so different news will be displayed.

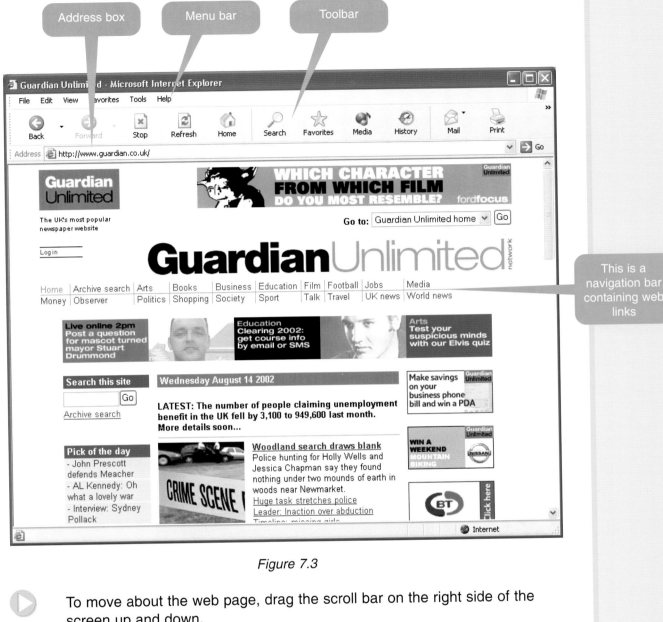

Figure 7.3

▷ To move about the web page, drag the scroll bar on the right side of the screen up and down.

▷ Web links join pages together and they often appear as underlined text. When your mouse pointer is on a link, the cursor turns into a hand. To move to another page, click a link with the left mouse button.

▷ To move backwards and forwards between web sites, click on the Back button with the left mouse button to go back a page and on the Forward button to go forward a page.

▶ Now practise accessing different web sites by typing in their address in the address box and clicking Go.

▶ Also, follow some of the web links on the pages and use the Back and Forward buttons to move between pages.

🛈 www.bbc.co.uk

🛈 www.cocacola.com

🛈 www.familyrecords.gov.uk

🛈 www.louvre.fr

Figure 7.4

What's a domain name?

Every web page has a unique address, for example **www.bbc.co.uk**

where:

www means world wide web and

bbc.co.uk is the domain name. These have to be registered with a special Internet agency after they have been researched to make sure they are unique. After they have been registered these domain names usually have to be paid for every few years to keep them active.

Domain names are spoken just the way they're read, so whenever you see a full stop (.) you say *dot* and a forward slash (/) is referred to as *slash*.

For example:

www.bbc.co.uk/news would be said out loud as

www dot bbc dot co dot uk slash news

Tip:
The endings of domain names can give you clues as to the country or type of organisation that the URL belongs to.

International companies often end in **.com** and URLs ending in **.co.uk** usually mean a company from the United Kingdom. Other examples are; France **.fr**, Germany **.de**, and .Italy **.it**.

Other codes include **.gov** for government, **.org** for organisation, **.ac**, **.ed** or **.sch** would suggest a university, college or school.

Finding things on the web

Finding web sites is easy enough when you know their web addresses, but what happens when you don't? Well that's when you need a search engine to help you out.

Search engines are a bit like reference libraries. They are powerful web sites that archive the content of the web into searchable databases.

Search engines work in the same way as the database searches you might use in your local lending library: you type in a keyword or query and the site then returns a list of web sites containing your chosen word or phrase.

Examples include:

www.altavista.co.uk

www.lycos.co.uk

www.google.co.uk

Figure 7.5

Another useful resource, which is slightly different to other search engines, is Ask Jeeves (www.ask.co.uk). In addition to using keywords and phrases to search for a specific topic, you can also pose questions in plain English, which Jeeves will attempt to answer.

Assume we want to find out the times of the trains from Ipswich to London Liverpool Street.

▶ In Internet Explorer type **www.ask.co.uk** in the address box and click Go.

Figure 7.6

▶ Type your question Where can I find train timetables? into the search box.

▶ Click the Ask button.

If he thinks your question was a bit vague, Jeeves will display a screen featuring further questions that you can use to narrow down your search.

Figure 7.7

If one of the questions is more precise you can click on the drop-down menu box next to the question to select a suitable search term and then click Ask. Instead look at the bottom half of the results page where Jeeves will display the web address of any sites that he thinks are relevant to your original question.

Look through the list (you may need to go the next page of results) and click on Welcome to UK RAILWAYS on the Net (www.rail.co.uk).

Figure 7.8

64

 Click on Timetables on the Net.

Figure 7.9

 Enter your starting station, destination station, date and time of travel and click the Submit button.

Figure 7.10

The information you requested should be displayed.

Adding a bookmark

If you often have to travel by train to different destinations you might want to bookmark the web page so that you can quickly access it again whenever you need to.

▷ Click the Back arrow to return you to the timetable search shown in Figure 7.9.

⭐ Favorites

▷ Click the Favorites button on the Internet Explorer toolbar.

▷ In the window that appears click Add.

Re-name the entry here

Figure 7.11

▷ In the Add Favorite box change the name if you wish and click OK.

The next time you want to look up a train timetable simply click the Favorites button and a list of your favourite sites will be displayed in the left pane. You can choose the web page from the list.

The re-named entry

Figure 7.12: Choosing a page from Favorites

Printing a web page

Printing a copy of a web page onto paper is similar to printing a document you have created in a word processing package.

 With the timetable results page displayed on the screen select File, Print.

Figure 7.13

 Check the print options and then click Print.

Tip:
Check you
are only printing
one copy.

Tip:
To find out
more about the
Internet look out
for *Internet Right
from the Start* -
another book in
this series.

67

Chapter 8
E-mails

One of the reasons that many people choose to connect to the Internet is e-mail. It has become one of the most popular forms of communication.

E-mail allows you to send a text message from your PC to anyone, anywhere in the world that will arrive almost instantaneously and all for the price of a local phone call.

There are two types of e-mail. The first is the kind of account you are given when you sign up with an ISP. To use this type of account you need a special program that allows you to connect to the Internet and collect your mail. One of the most popular ones is Outlook Express, which is supplied with the latest versions of Windows.

The second type of e-mail is called webmail. Instead of using a separate program to read and write your messages, you sign up for an account with a web site. You then have to log on to the Internet for all your e-mailing. One great advantage of webmail is that you can pick up your e-mails from any computer connected to the Internet. Examples include Hotmail (**www.hotmail.com**) and Yahoo! Mail (**www.yahoo.com**).

E-mail addresses

When you sign up for an e-mail account either with a webmail service or with an ISP, you'll get your own unique e-mail address.

E-mail addresses are similar to web site addresses. They are always in this format:

username@domain_name

The username is the unique name you have chosen and domain name is either the ISP or a web site address.

For example:

someone@hotmail.com

someone-else@freeserve.co.uk or

someone@payne-gallway.co.uk

Warning:
You must enter an e-mail address correctly or the mail will come back undelivered.

_ Mail provides the following
at benefits:
rivacy: Only you can access it
 your password.
nywhere Access: All you need
n internet connection to access
r AOL mail account.
ecure: Your information is safe.

EUDORA

WebMail

Privacy Policy

Sign-Up Here
Learn more
Login Trouble

Registered Users

Enter User Name:

Enter Password:

login

Forget your password?
Here's a hint.

Visitors

• Sign-Up **for your own free personalized E-mail!**
• Learn more **about Eudora's Web-Mail.**

Updated User Policy
You must log in at least once every 3 months to keep emails from being deleted in your account.

YAHOO! Mail

Help-Yahoo!

Welcome to Yahoo! Mail

You must sign in to read or send mail.

New to Yahoo!?
Sign up now **to enjoy Yahoo! Mail**

• Yahoo! Mail is FREE - sign up now!
• Get your emails via Sky TV
• 6MB of FREE email storage space
• Filter unwanted mail with SPAMGUARD
• Get instant notification when you have new messages with Yahoo! Messenger

more about Yahoo! Mail

Existing Yahoo! users
Enter your ID and password to sign in

Yahoo! ID:

Password:

☐ Remember my ID on this computer

Sign In

Mode: Standard | Secure

Sign-in help Password lookup

IMPORTANT!
Yahoo! has an updated Privacy Policy which contains new information, including sections on Web Beacons and Cross Border

Setting up a Hotmail account

To use Hotmail you first have to register with them and secure an e-mail address.

▶ Log on to the web site **www.hotmail.com**. You will see a screen similar to this:

Figure 8.1

▶ Click on free E-Mail Account.

Figure 8.2

 Complete the registration form as requested.

If the e-mail address you chose is already in use by someone, you will be given some similar ones to choose from.

Figure 8.3

You will be presented with a couple of screens offering you newsletters and other promotional material – it's up to you if you sign up for any of these!

Finally you will receive confirmation that you are signed up as a Hotmail user.

Figure 8.4

 Click on Return to Hotmail.

You will see the Home page.

Figure 8.5

Receiving messages

Incoming messages are stored in your Inbox. You will have received one message welcoming you to Hotmail.

 Click on either the Inbox link or the Inbox tab (Figure 8.5).

A list of your messages will be displayed.

Figure 8.6: Accessing your messages

 Click on the message to read it.

Sending messages

▶ Click on the Compose tab.

▶ Type the e-mail address you are sending to in the To: box.

▶ Type something in the Subject: box to say what the message is about.

▶ Type your message in the main window.

Figure 8.7: Sending a message

▶ Click the Send button.

You should receive confirmation that your message has been sent.

Using the Contacts list

The Contacts list stores the e-mail addresses of people that you regularly send e-mails to so that you don't have to type in their address each time.

Click here to save the address in your contacts list

Figure 8.8

 Check the Save Address box and click Save.

This will save the e-mail address as one of your regular contacts. You can assign it a short name to save you having to type in the whole address every time.

Figure 8.9

Sending an attachment

As well as sending the message you type into Hotmail you can also attach another file to the message. This might be a document that you have prepared in a word-processing or spreadsheet package or perhaps a photograph you want to send to a relative.

You attach a file from the Compose window (Figure 8.10).

▶ Compose your e-mail and then click Add/Edit Attachments.

Figure 8.10

▶ In the next window, navigate to the file using the Browse button and then click Attach.

Figure 8.11

When the file appears in the Attachments box, click OK.

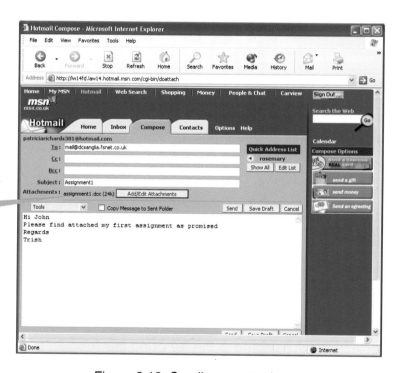

Figure 8.12: Sending an attachment

You will return to the Compose screen where you should see the name of the attached file. Click the Send button to send the message and the attached file.

If you open a message that has an attachment you will see the name of the attached file. Click on the file name to download it.

Note:
You can't send very large file attachments with Hotmail.

The attached file

In Chapter 5 you inserted a clip art picture into your poster. There are other ways of acquiring pictures for your documents or pictures that you want to e-mail to friends.

Scanning pictures

A scanner allows you to save a printed picture as a file on your PC. You can then print the picture, incorporate it into another document, use it on a web site or e-mail it to someone else.

Most scanners work in a similar way – you will need to follow the manufacturer's instructions for setting it up. They are all supplied with software that allows you to specify the type of image you want to scan along with resolution (or quality) and colour settings. Some scanner software also allows you to edit the images you scan.

This example shows VistaScan software being used to scan a small area of a book cover.

▶ Load the scanner software program from the Start menu. You will see a screen with options similar to this.

Figure 9.1

▶ Place the document to be scanned in the scanner and click on Preview. You will see the image on the screen.

Drag the dotted lines around the area you want to scan

This sets the resolution in dots per inch

Figure 9.2: Previewing the scan

▶ Use the mouse to drag the dotted lines around the area you want to scan and click Scan.

You may be asked to specify where you want to save the image, or the software may default to a particular folder – make sure you know where the file is being saved.

Figure 9.3

Once the image has been scanned you can insert it into a Microsoft Word document.

▶ In a new Word document select Insert, Picture, From File.

▶ Find the scanned file and click Insert.

The image will be inserted into the document and you can size it as required.

Reminder:
Look back at page 37 to remind yourself about sizing pictures.

Figure 9.4: The scanned picture inserted into a Word document

Pictures from a digital camera

The main benefit of a digital camera is that you can transfer your photos directly to your PC without sending a film off to be developed.

Using a digital camera is very similar to using a traditional camera. They both use the basic components such as a lens, flash, shutter and viewfinder. Most digital models now incorporate an LCD screen so that you get a good of view your subject as you take the photo, and you can then review the pictures afterwards.

The quality and number of digital pictures that can be taken will depend on the amount of memory in the camera.

Most digital cameras are now USB devices. This means that a cable supplied with the camera can connect it to a USB port on the back of your PC.

To operate your camera you should refer to the manufacturer's instructions. When you have taken your photos and connected the camera to the PC a new 'virtual' drive will appear on your computer. Displaying the contents of this drive in My Computer will reveal a list of files.

Tip:
Universal Serial Bus (USB) ports are supplied on most desktop PCs. They can be used to connect different devices such as scanners, modems, printers and speakers

Downloading from the Internet

You can instantly boost your record collection by downloading music from the Internet. Music files are quite large and can take up a lot of space on your computer. They can also take a long time to download from the Internet. Ideally you need to find Internet sites that have free MP3 downloads. MP3 is a technology which allows a music file to be compressed to a fraction of its size.

You can try the site of your favourite artist or some of these:

www.mp3.com	www.besonic.com
www.vitaminic.com	www.emp3finder.com

Special programs are available to manage the music files you download and to play the music on your PC. However to begin with you can try playing the files using Windows Media Player.

 Log on to www.vitaminic.com

Figure 10.2

Click on one of the music categories on the left or one of the Spotlights, for example Steely Dan.

85

Figure 10.3

Careful - they're
not all free!

Scroll down the list of songs and click on the one you want to download.

Windows Media Player will automatically open to prepare to play the music that is
being downloaded.

Figure 10.4

 If you have enjoyed the track and would like to save it then disconnect from the Internet and click File, Save As from the main menu bar.

A Save As dialogue box will appear inviting you to save the file in the My Music folder.

Figure 10.5: Saving the MP3 file

 Change the file name if you wish and click Save.

When you want to play the track again find the file in My Computer and double-click it. Media Player will automatically open and play the music.

Recording your own music

To record sounds using Microsoft Windows you need to have an input device connected to the computer, such as a microphone or an electronic music keyboard.

▶ Begin by checking the device is not muted, by selecting Start, All Programs, Accessories, Entertainment, Volume Control.

Figure 10.6

▶ Select Start, All Programs, Accessories, Entertainment, Sound Recorder.

Figure 10.7

▶ Click the Record button and speak (or sing!) into the microphone.

▶ Click the Stop button and then click Play.

You should hear your voice being played back – if you've remembered to switch on the speakers!

▶ Use the Effects menu to increase or decrease the volume of your recording.

▶ Use the File menu to save your sound file.

Chapter 11
Troubleshooting

PCs are rather like cars – they're great when they are working, but oh boy can it be a problem to you when they're not.

It is surprising how quickly new PC users start to depend on their computer system and how frustrating it can be when things go wrong.

In this chapter we look at some basic things you can try when you get a problem, and also some preventative measures you ought to take to stop the problems happening in the first place.

Problems while you are working

Using Undo

If you are creating a document and you do something that you instantly wish you hadn't, don't panic. Most Windows programs will allow you to undo at least your last action. Some programs allow you to choose which previous action to undo from a list. Usually the Undo command is found in the Edit menu and sometimes an Undo button is included on the toolbar.

Saving your work

All the previous chapters have instructed you to save your work regularly. It is a PC user's worst nightmare to be typing a long report for homework or for work and with no warning your PC crashes. If you have saved your work after every half page or every few minutes, whichever is most appropriate, it will pay off in the end. Most Windows programs allow you to save an existing document quickly and easily by clicking the Save button on the toolbar.

Some programs also perform automatic saves at intervals that you can preset. If the computer crashes, the program will recover the document from the last save it performed when the PC is restarted. This is called Autorecovery.

Switching off your computer

Before you switch off your computer you must close any programs that are open. You should then close your computer down in a certain way. If you do not do this and just switch off, your computer will not restart normally next time.

▷ When you have closed all your programs you should see only the Windows desktop on the screen.

▷ Select Start, Shut Down.

Figure 11.1

▷ In the box that appears click Turn Off.

Figure 11.2

▷ Wait for the screen to go black, or for a message to say that it is safe to turn off your computer.

▷ Power off the computer.

Tip:
With Windows 2000 upwards, the PC switches itself off – but don't forget to turn the screen and printer off.

Virus Checking

Viruses are designed to create problems with your PC, or at least to cause you some inconvenience. At worst they can wipe all the data saved on your hard drive. All PCs should have virus-checking software installed. The package should be capable of scanning and clearing viruses from the system. As new viruses are being discovered regularly it is recommended you install a package that provides an on-line update service, such as Norton AntiVirus.

Figure 11.8: The Norton AntiVirus utility

The dramatic proliferation of viruses over recent years is due in part to e-mail communication.

Never open an e-mail attachment from someone that you don't recognise – it could well introduce a virus into your system.

So that's it – now you're ready to move on to some of the other books in this series!

Tip:
If your package provides on-line updates, you will receive a message to remind you to update which can be done on-line.

Index